UNKNOWN HEBRIDES

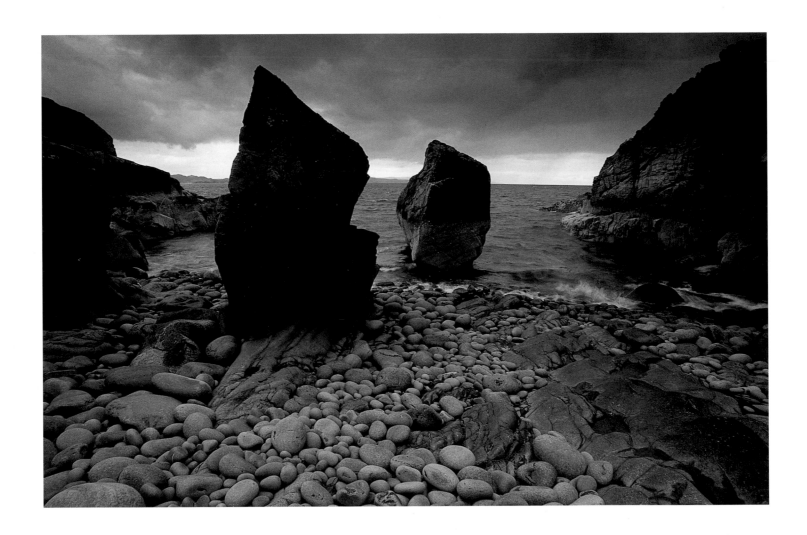

Small rocky bay on the west coast with rock sentinels, Priest Island

UNKNOWN HEBRIDES

PHOTOGRAPHS BY
JOHN MACPHERSON

WITH AN INTRODUCTION BY
HAMISH HASWELL-SMITH

First published in Great Britain in 2005 by
Birlinn Ltd
West Newington House
10 Newington Road
Edinburgh

www.birlinn.co.uk

ISBN10: 1 84158 352 9
ISBN13: 978 1 84158 352 5

British Library Cataloguing-in-Publication Data
A catalogue record for this book is available on request from the British Library

Design by Andrew Sutterby

Printed and bound by L.E.G.O, Italy

PREFACE

THIS BOOK is a visual record of my experiences during an intense period of photography during 2004, capturing a series of 'snapshots' of a varied selection of islands. It is not intended to be an exhaustive guide to the many islands off Scotland's west coast, Hamish Haswell-Smith's beautifully illustrated books are the gold standard in that regard. I have tried to record aspects of the social history, natural history, and any contemporary human activity I encountered, all illuminated by the weather on the days I visited. The images portray whomever I was fortunate to meet at the time; and in some respects these images also reflect my mood on the day, and the things that often caught my eye as a result. But I would like to think that they contain something more than that, and are perhaps able to impart to the reader a little bit of the magic these places possess.

I have to admit to a soft spot for islands, an affinity indelibly etched in some small but significant corner of my psyche. I am descended on my fathers side from Mulleachs (Bunessan), with a little bit of Spanish seafaring blood from the Armada thrown in, and I imagine this has something to do with it. Childhood adventures with my parents in our small wooden boat on Loch Linnhe often led us to the islands off Corpach. Only a short distance from Fort William and our house near the town pier, and only very small islands which almost disappeared at high tide, but big enough to overwhelm the imagination of a small boy.

And later in life my first experience of seakayaking made me realise that the ocean, for all its unpredictable dangers, is an astonishing place, and the things contained within that vast body of water are fascinating....and that includes islands.

So, to be asked to do a project on "Islands That Are Hard To Get To" (as it was initially put to me) seemed an opportunity not to be missed, and one that immediately excited me. This title, subsequently 'softened' to "Unknown Hebrides", is a slight misnomer, as many of these islands are fairly accessible. But you need to work at it! I did lots of reading, making phonecalls, weather-watching, car-driving, followed by intense bouts of dodging about on fishing boats and hitching lifts on yachts. It also involved a fair amount of rock-leaping, followed later by deck-leaping as I tried to get back aboard the waiting craft! But a few islands needed no more effort than a look at CalMac's timetable for the regular ferry to gain access.

Sceptical friends asked me "What exactly, after the first island you visit, are you going to photograph that will differentiate one from another? I mean, when you've seen one lone jaggy rock you've seen them

all." And I confess that initially this bothered me slightly! Just a little niggle, what if they were right.... The reality? Each island is so different from its neighbours....the landscape, the vegetation, wildlife, the backdrop, even the weather.... that I was never short of photographic subjects.

Many islands, such as Soyea, South Ascrib and the Garvellachs now have no residents, other than the birds, and the occasional day visitors. But Lismore, Kerrera, Soay, Raasay and other islands do support permanent residents. Lismore was a grand experience! A total stranger loaned me a car as I walked along (thank you Lillian), and so I was more easily able to get about and meet many of the other inhabitants of this beautiful and thriving island. But more than anything else that affected me was the absence of people that was such a notable aspect of the majority of the islands I visited.

My experience of being on so many now uninhabited islands, away from the tarred roads of mainland Scotland, and apparently 'on the edge', underlined for me how important our coastal seaways would once have been, far more important than any inland track. Islands that are now remote and seemingly unimportant would once have been hubs in these seaways, vital refuges from stormy seas, sources of water or food, and places to settle, raise families and make a life in. And from such places have grown the stories and traditions that have informed and inspired our rich literary and musical heritage. We owe a vast debt to such places, to the stark but inspirational beauty and wildness of these island land and sea scapes. But it was often with a profound sadness that I wandered through the all too numerous crumbling ruins I encountered, overgrown, the stories of the lives they'd seen now half-forgotten.

"Many songs they knew who now are silent.
Into their memories the dead are gone
Who haunt the living in an ancient tongue
Sung by old voices to the young,
Telling of sea and isles, of boat and byre and glen;
And from their music the living are reborn
Into a remembered land,
To call ancestral memories home
And all that ancient grief and love our own."
(from 'Highland Graveyard' by Kathleen Raine)

Scotland's islands are unique, many have a fascinating social history, and some, thankfully, support vibrant and growing communities, others have quite astonishing wildlife, but all possess their own unique atmosphere. My favourites? Well, they all have their charms, but Raasay and Eilean a'Chleirich (Priest Island) particularly impressed me. One is inhabited, the other not. Sorley MacLean's poem 'Hallaig' says more than I could ever hope to about the history and infectious atmosphere of Raasay. It is a place overlooked by Skye, but in no way overshadowed. Eilean a'Chleirich? Well....this is a purely personal thing, and it has to do with the shape and form of its landscape, the colours of the rocks, its situation -

surrounded by the mountains of Wester Ross & Sutherland - and possessed of that indefinable magic that some places just seem to have.

Highs and lows? Unbeatable high was being on the Garvellachs with nothing to see but islands. Mull, Colonsay, Islay, Jura, Scarba, Lunga, Fladda, Belnahua, Luing, Seil, and even the Western Isles, in crystalline light. The low? It has to be lying in my sleeping bag on Scarba on a cold, wet, dark and squally summer day, rain spattering the tent, with innumerable ticks crawling on my arms, legs and most points in between.

Scotland is a special place, and its islands even more so. Visit them if you are moved to, and are able to, but above all cherish them, for they are unique.

I need to thank the many people who made this book possible. It's easy to think that this is all the result of me, camera in hand wandering about alone doing arty stuff. The reality is much different! There are numerous people whose considerable efforts made my work possible.

From north to south, warm thanks are due to:

In Sutherland, Meryl Carr for loads of help, advice and contacts; the late John Smith, Elspeth & Ron Davidson, and Elizabeth Drake, Rona Eddington, Gillian Slider and Jennifer Gemmel from Ullapool High School for the assistance on Isle Martin; Steph Elliot (RSPB) and her colleagues Ian, Dave, Rosemary, Alan, Kevin and Helen on Priest Island, and a big thanks to fisherman Hamish Sinclair for the voyage back to Old Dornie and the beer and crack on the way; and to Neil and Tina Lloyd-Jenkins for the Soyea trip on a perfect west highland day.

On and around Skye, Donnie McKinnon, Pete Naylor and Paddy Smith, and Alan Simmons for assistance getting to South Ascrib; Rebecca and Calum Don McKay, and Jan Burnett for welcome blethers, soup, tea and drams on Raasay. Murray Stark from Inverness College Seafield Aquaculture Unit at Kishorn for getting me safely to the Crowlin Islands, and a big thankyou to the unknown owner of the boat *Annie Pack* from Portree for the spare petrol you gave us which we really did need to get us home again!

In the Argyll area, I owe a huge debt of gratitude to Duncan Phillips (Farsain Cruises 01852 500664) for his expert boat handling amidst far too many jaggy rocks, and to Rae and Steve MacDonald for the company and laughs, and the drams and welcome bed in Tarbert after the Garvellachs trip. On Lismore, Lillian Colthart (thank you for the car!), Iris MacColl, Pete and Heidi Walker, Robert Mitchell, Ewen MacPherson and Roger Dixon-Spain. Thanks to Nigel Dyckhoff for the welcome mug of steaming tea on a foul and stormy Luing day.

Warm thanks also to old pals Ronnie Weir and Stewart Wilkinson for the trip to Soay on their yacht *Santana* and to Jan & Ian Lovett for the hilarious tales of Tex Geddes when we got there, sat comfortably in your garden with a large and welcoming dram. A big thanks to Hugh Andrew, Jim, Liz and the staff at Birlinn for the opportunity to do all of this, and to Melanie and Corrie the collie for the welcomes home.

I am grateful to you all for your cooperation and often considerable efforts. This is only a wee book, but its your book too.

John MacPherson

ISLAND LISTING

INTRODUCTION

JOHN MACPHERSON has a remarkable talent. Any attempt to photograph our lovely islands definitively is an impossiblity as they are all so physically diverse. Apart from that, each specific scene is forever changing with startling rapidity due to the mercurial quality of the light – a continual moving picture of form and colour which never fails to fascinate. But John uses a camera as an artist uses a pencil or brush. He has an artist's knowledge of composition and colour, and the ability to recognise and capture inconsequential detail and turn it into a hidden story.

I must confess that for years I have tended to use photography as nothing more than a mechanical means of recording what one sees at a particular moment of time. An exact and detailed record of what is there – leaving nothing out. Sometimes a beautiful record, but just a record nevertheless. For me, it had to be a sketch or a painting that captured the artistic essence of an object or a scene or an island. After all, I reasoned, a sketch has been distilled through the mind of the artist. The inconsequential – the intrusive rubbish – has been eliminated. Photography certainly has the advantage of speed; a convenient means of capturing a cloud shadow as it races across a hillside, the elusive glint of atmospheric sunlight on the sea, the splash of water on a rock, but a photo was, in my restricted view, merely an aide memoire to recall an incident or a moment of transient beauty.

But that viewpoint is much too limited because the photography of John MacPherson is art in its own right. He has picked a disparate group of islands in the Inner Hebrides and painted each one in all its startling individual beauty and with an art which also manages to capture the particular history and psyche of that small piece of land set in its patch of silver sea. Each picture when studied carefully tells a story.

The more one gets to know these islands the more you realise how distinctly different they are. The peace and friendliness of Lismore, the mysticism of Eileach an Naoimh, the rugged masculinity of Scarba, the sheer beauty of Raasay, the loneliness of the Crowlins and the Ascrib isles – one could go on and on.

As far as his choice of islands go, I am glad that John has included tiny Belnahua. It is so often passed by. This is an example of an island that survived the Clearances, potato famines, Salt Tax and kelp slump yet it had no fresh-water supply and no agricultural land whatsoever. The entire island is made of slate, so it gave its inhabitants an assured livelihood providing roofing material for the burgeoning Victorian cities at a time when many other islands faced

destitution. As the city populations were growing exponentially slate was in ever-increasing demand. Belnahua is a very small island but it strove to meet the need. More and more slate was quarried until so much had eventually been removed that the island almost literally broke its back. Eventually the inhabitants left, the quarries filled with water, and those poignant rows of workers' cottages still stand roofless – silhouetted against the sky like broken teeth. But there is a forlorn beauty here and, after all, even the name – Belnahua – has a South Sea island sound of paradise.

Dún Chonnuill is also one of these tiny uninhabited islets that are rarely visited partly because landing is not particularly easy. It supports traces of an ancient dún (iron-age fort) and a castle or keep, probably built by Maclean of Duart. Both these remains are so vestigial that there is not much to be seen but the islet still seems to say that for all its insignificance it is courageous and defiant and perfectly capable of repelling any intruder. This seems to reflect its association with Sir Fitzroy Maclean – known to the Foreign Office as 'Fitz-whiskers' – who had something of the same qualities. He held the title of 15th Captain and Hereditary Keeper of Dunconnel in the Isles of the Sea. The dashing Maclean carried out many daring exploits during the Second World War both with the SAS and Tito's Partisans in Yugoslavia, and it is said that he was the role model for Ian Fleming's James Bond. His son continues the ancient title of Keeper of Dunconnel.

Looking to the north, Eilean a' Chléirich, or Priest Island, is another interesting choice. Lying alone in the milk-blue waters of the Summer Isles it must, to account for its name, have sheltered an anchorite at some time in the past. Since then, however, and after a century or two of solitude, it became more wordly. An 'outlaw' moved in and apparently produced three generations of crofters before the island was abandoned again but not entirely deserted as, like many of our islands, it became a vital source of illegal whisky. The story goes that distillation took place by the wee burn running from Lochan na h'Airidh and – the 'worm' – the curling copper pipe which is the most expensive part of the apparatus, is still reputed to lie at the bottom of the Lochan. The raw spirit was stored in a deep cave in the south-east corner of the island ready to be smuggled ashore. The smugglers kept some sheep on the island as a diversion but whereas most island sheep were left to their own devices these men were extremely conscientious farmers and insisted on visiting their flock every week or two. All went well for a considerable time until the youngest smuggler chose to get married. One day, soon after he had left his home on the mainland to go and 'tend the sheep', a storm blew up and his young wife panicked. She called on the townsfolk to rescue him. They launched the longboat and rowed the eight miles to Priest Island, where they found the smugglers' boat drawn up on a small beach. Going ashore, they discovered the young man and his friends safe and well and happily hiccuping in the cave amid kegs of raw spirit. They may well have joined them, but unfortunately one of the crew was an exciseman.

Every island has its history and its anecdotes but it takes great skill to portray these characteristics in pictorial form. I mentioned how a sketch could eliminate the useless rubbish, the clutter and the garbage which inevitably accompanies mankind, and how this is not possible with film. But in the hands of a skilled photographer such as John, and without resorting to any digital gerrymandering, even clutter and rubbish is brought under control and made a part of the story. A good example of this is the photograph on p. 64 of a farm at Clachan, Lismore. The overhead wires would almost certainly be omitted from a sketch as a distraction from the point of interest — the farmhouse. A photograph, however, includes them by default — but John has turned this to advantage. His viewpoint carefully positions the wires so that they direct the eye towards the farmhouse. A small point, but that is art.

Of course, some human clutter is a work of art in itself. I sketched the Fisherman's Store on Soay (p. 67) probably seven or eight years before John photographed it and it has changed very little in the time. There is a strange forlorn beauty in which every individual artefact tells its own story of aspiration and despair, toil and abandonment. And the old boiler by the Shark Station (p. 66) is an example of John's ability to see a pattern and a story in everyday things. I was captivated by a blackbird nesting in its depths. He sees the contrast of rusting metal and green foliage as a composition in itself and depicts it strikingly.

All these photographs are worthy of study. They bring the islands to life. John's palette is the flow of water over stone, rust on old machinery, a lone wildflower, or the friendly face of a crofter or fisherman masking a life of toil and hardship. His scenes are touched with pathos — ruined crofts in lonely landscapes — but humour too — the vapour trail of a modern jet plane smoking from a ruined chimney.

Hamish Haswell-Smith

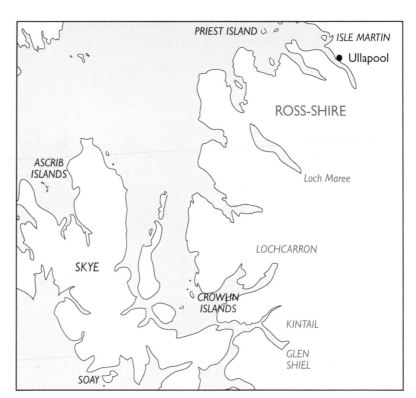

PRIEST ISLAND

ISLE MARTIN

● Ullapool

ROSS-SHIRE

ASCRIB
ISLANDS

Loch Maree

SKYE

LOCHCARRON

CROWLIN
ISLANDS

KINTAIL

GLEN
SHIEL

SOAY

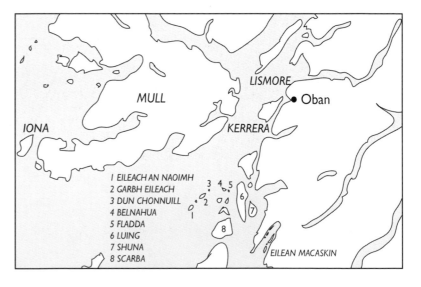

MULL

LISMORE

● Oban

IONA

KERRERA

1 EILEACH AN NAOIMH
2 GARBH EILEACH
3 DUN CHONNUILL
4 BELNAHUA
5 FLADDA
6 LUING
7 SHUNA
8 SCARBA

EILEAN MACASKIN

From the left-hand map:

ORKNEY

Cape Wrath

CAITHNESS

LEWIS

SUTHERLAND

HARRIS

N. UIST

ROSS-SHIRE

SKYE

MORAY

ABERDEENSHIRE

Inverness

NAIRN

Loch Ness

BANFF

S. UIST

INVERNESS-SHIRE

Aberdeen

KINCARDINE

BARRA

ERISKAY

CANNA

RUM

EIGG

MUCK

ANGUS

COLL

PERTHSHIRE

TIREE

MULL

ARGYLL

Dundee

IONA

Perth

FIFE

COLONSAY

STIRLINGSHIRE

Stirling

JURA

Edinburgh

ISLAY

● Glasgow

ARRAN

KINTYRE

Mull of
Kintyre

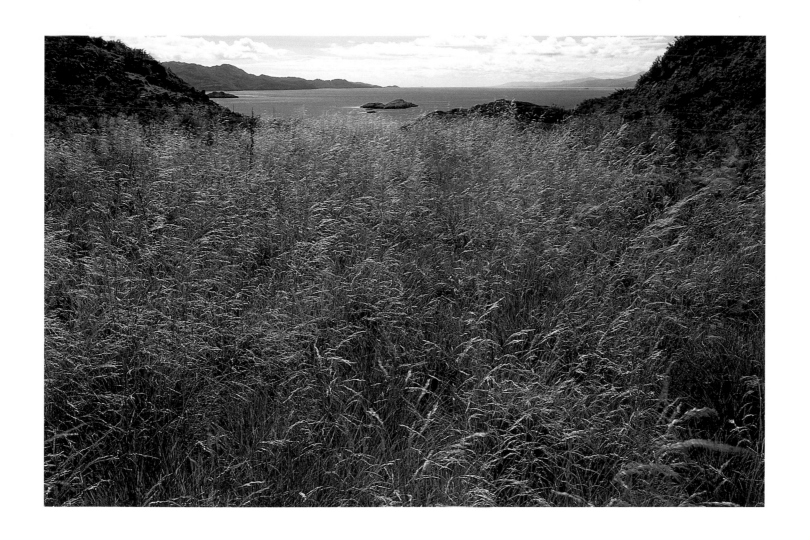

View south down the Argyll coast, with the Isle of Jura to the right

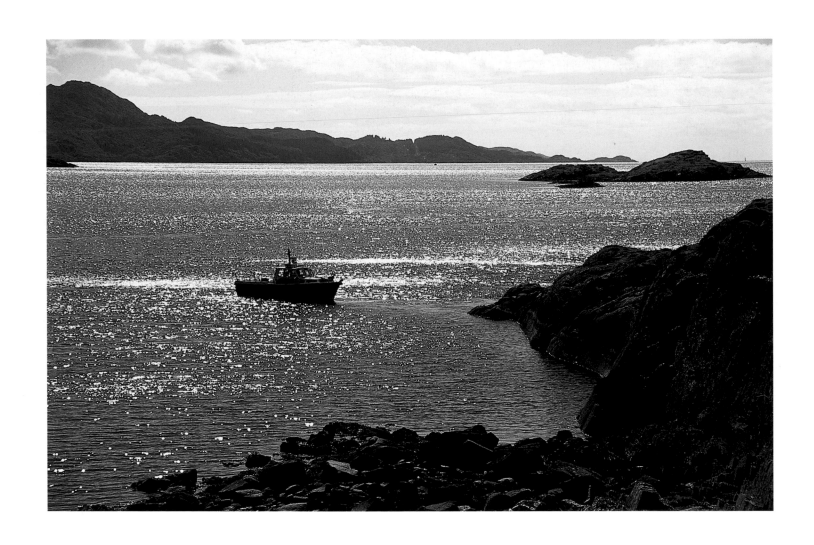

Our boat *Farsain*, ready to pick us up

Rowan tree in a small glen

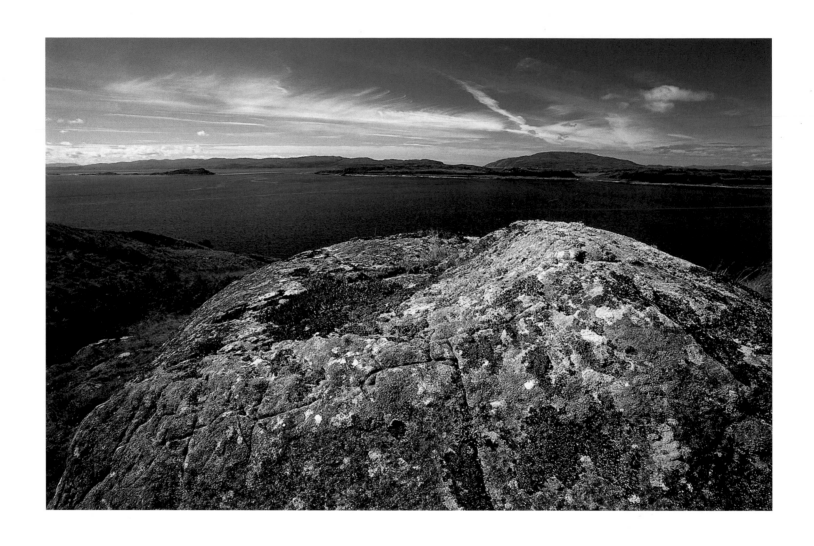

Lichen clad boulder, Jura behind.

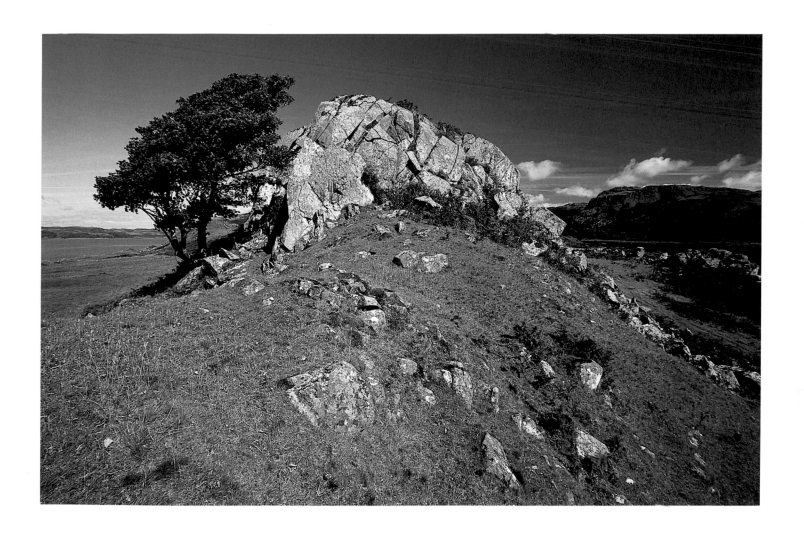

The rocky spine of the island

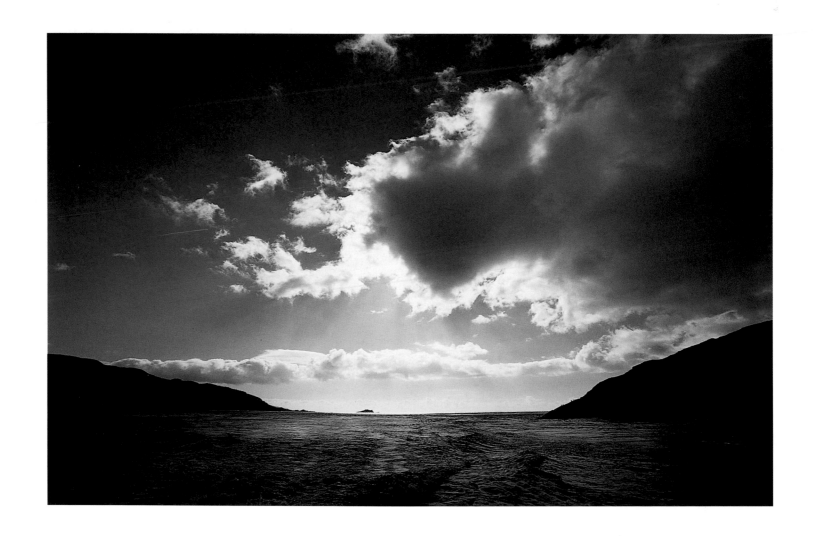

The Gulf of Corryvreckan from the sea in afternoon light

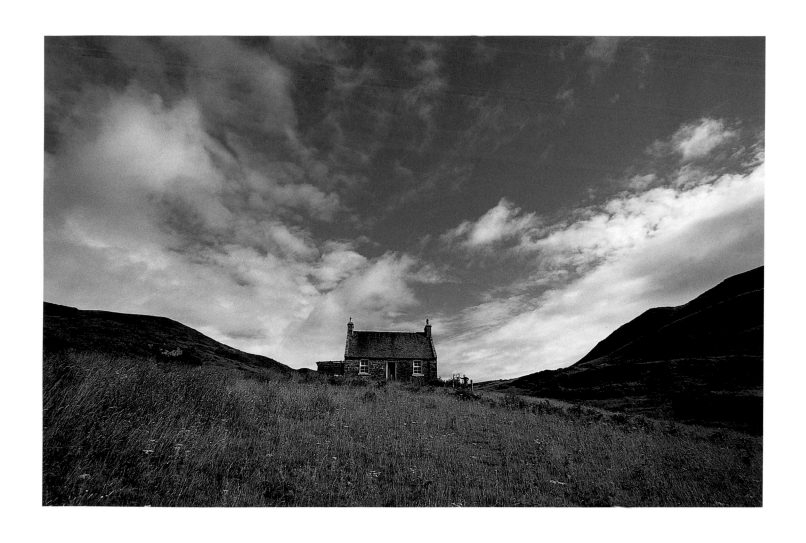

The bothy, Gleann a'Mhaoil Bay

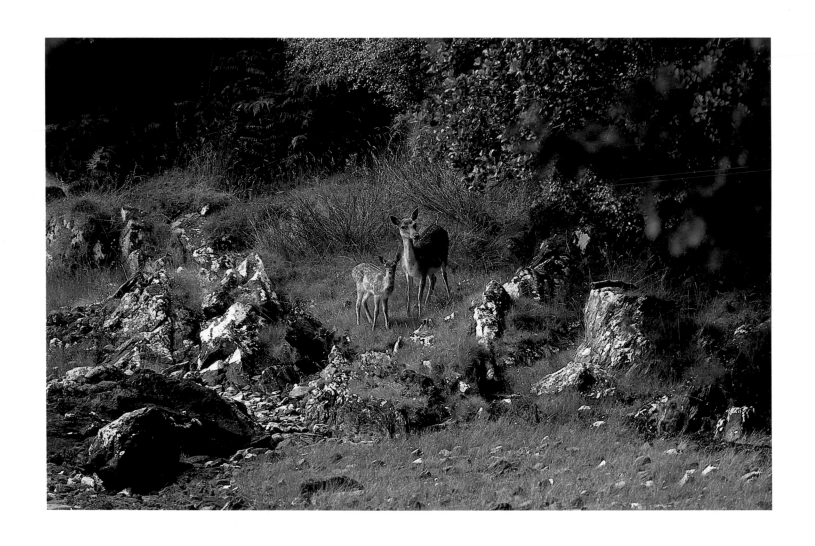

Fallow deer and fawn in a quiet moment

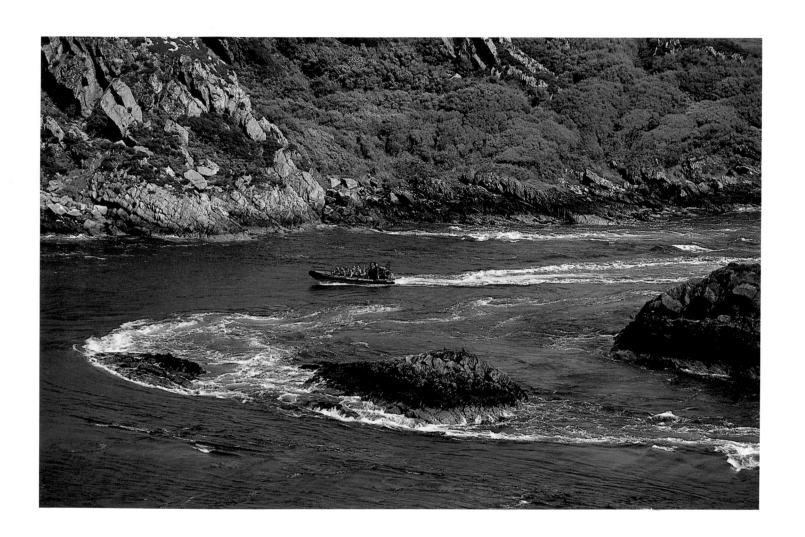

Pleasure trippers in a RIB playing in the Grey Dogs

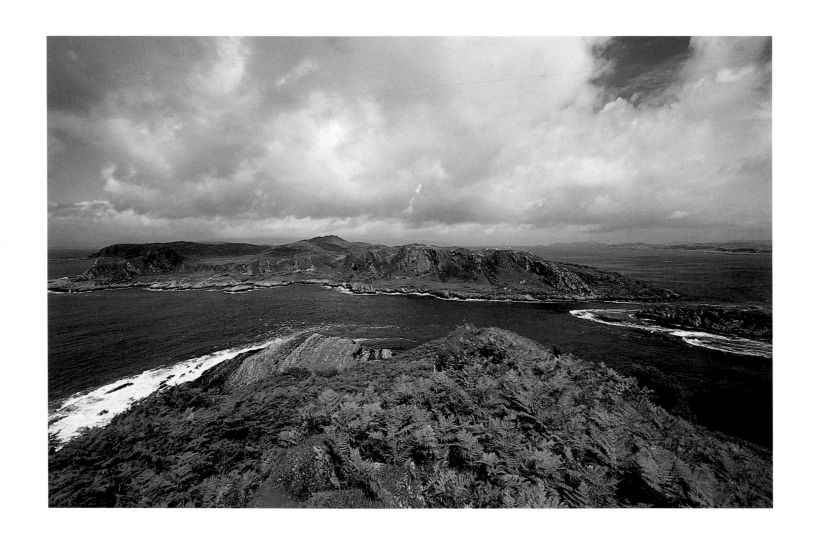

View to Lunga across the Grey Dogs from north end of Scarba

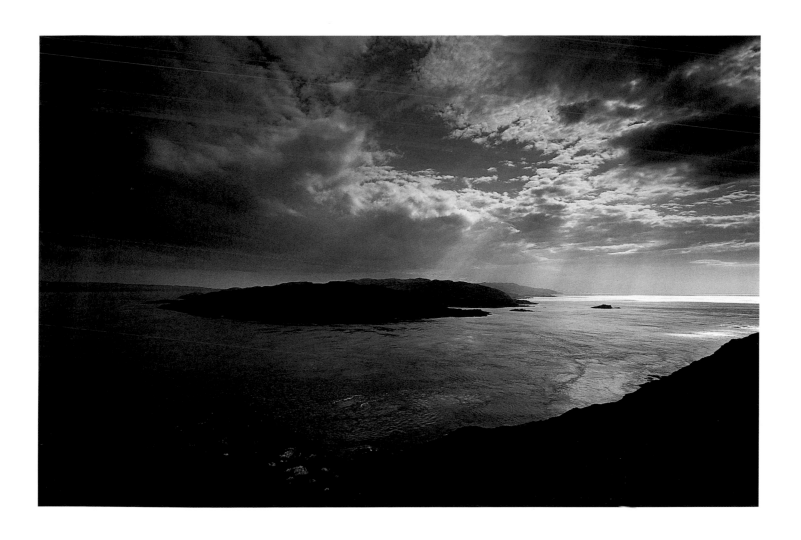

Jura & the Gulf of Corryvreckan

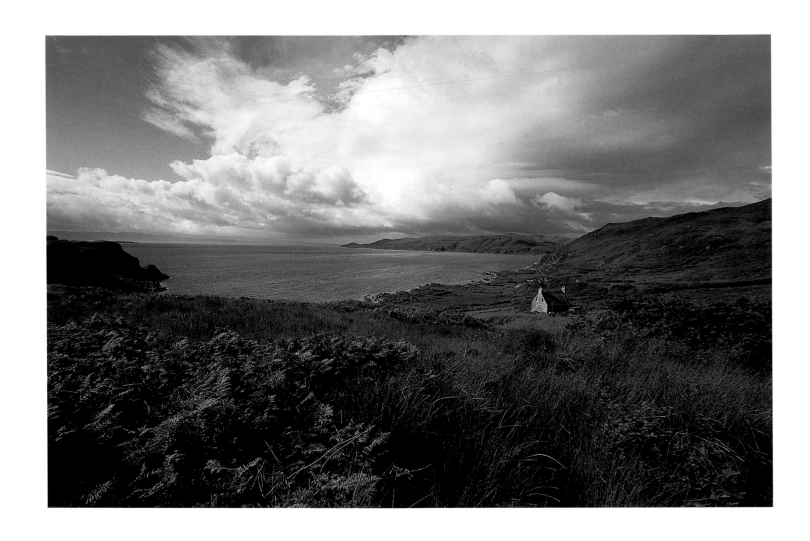

The bothy in Gleann a'Mhaoil Bay, Jura in background

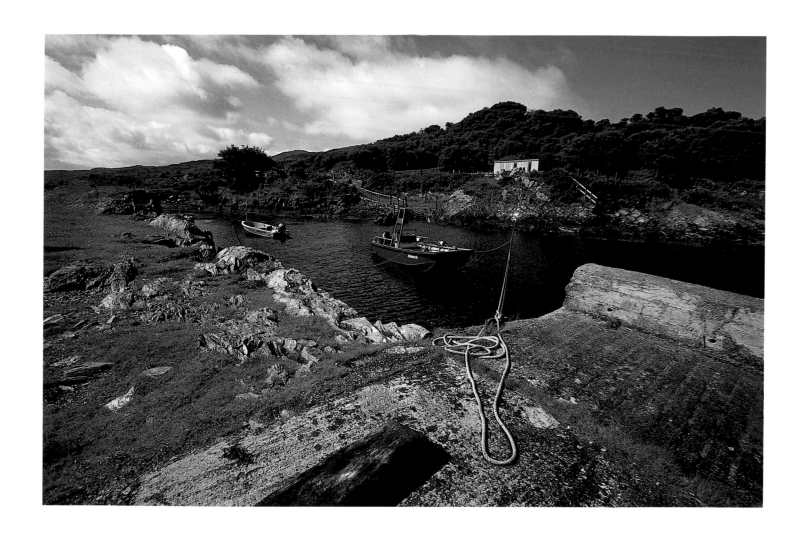

Poll na h-Ealaidh jetty

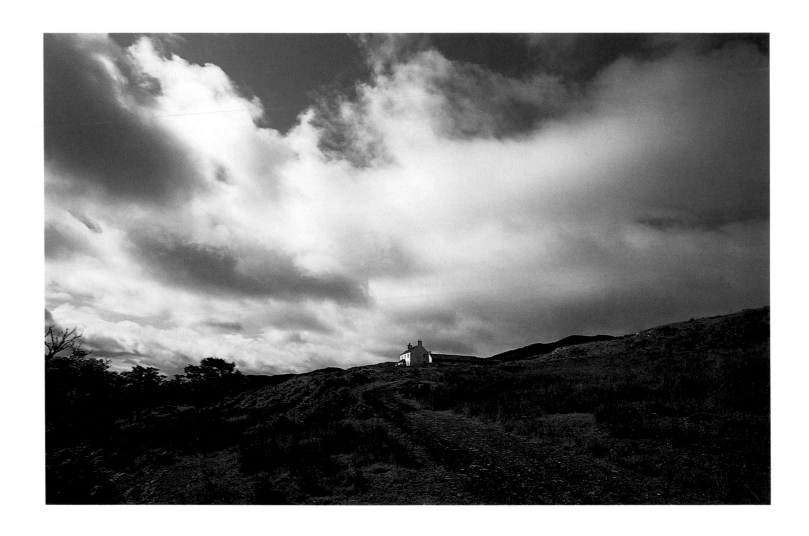

Kilmory Lodge

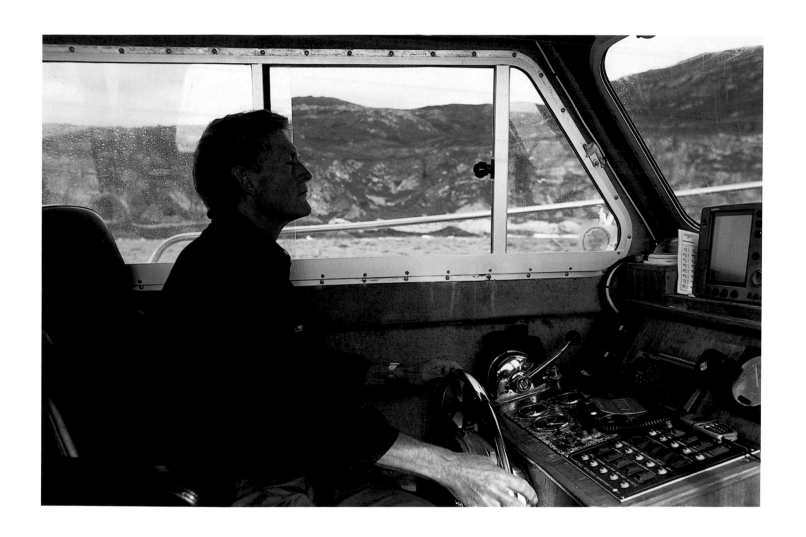

Duncan Phillips, owner and skipper of the boat *Farsain* off Scarba

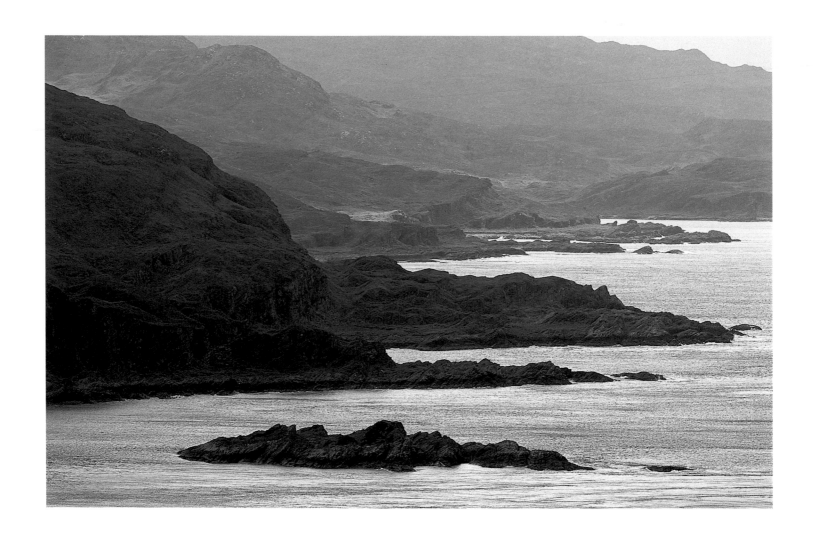

The wild coast of Jura, viewed from Scarba across the Gulf of Corryvreckan

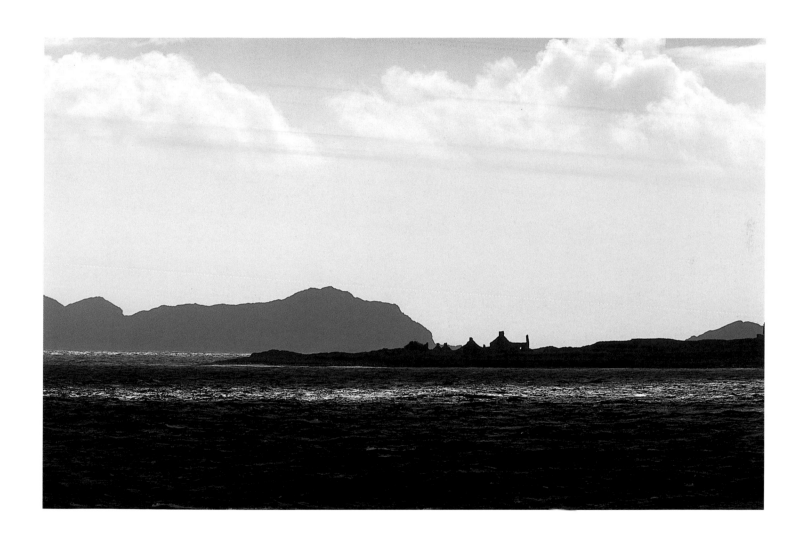

The island of Belnahua from the Isle of Luing

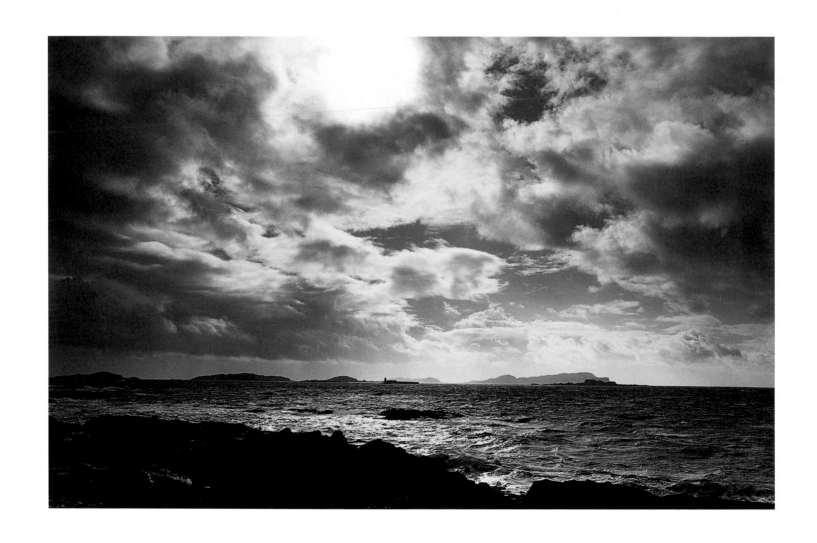

Stormy sky over the Garvellach Islands from Cullipool

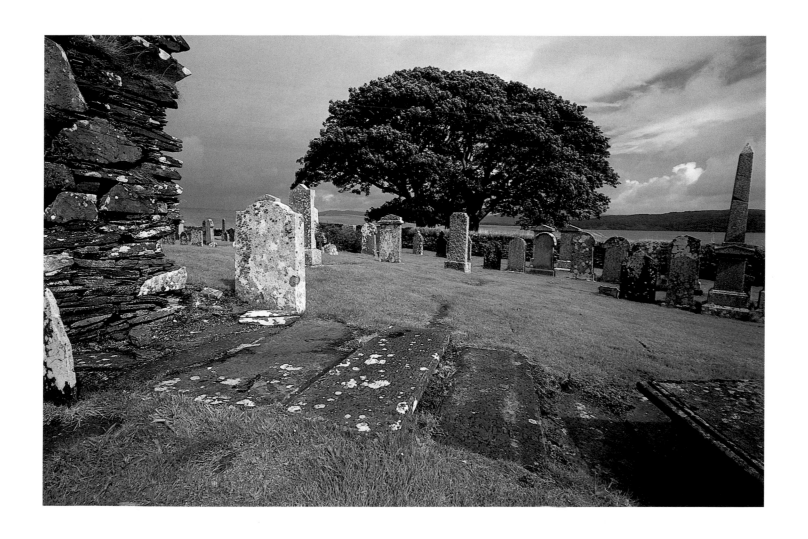

Grave stones in Kilchatton Chapel grounds, near Toberonochy

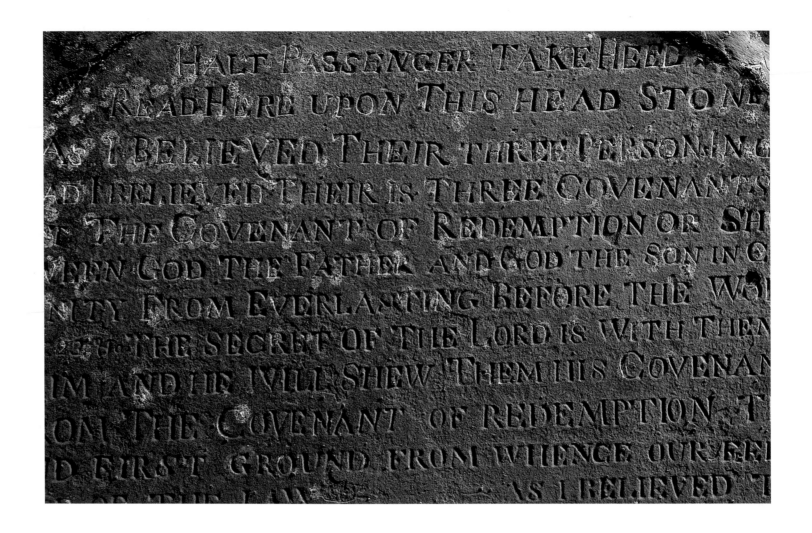

Inscription on a gravestone, Kilchatton Chapel, near Toberonochy

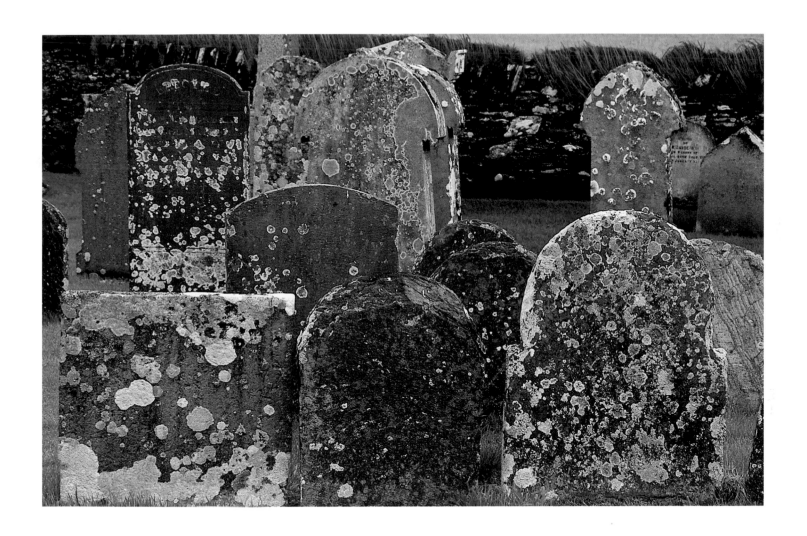

Pattern of grave stones in Kilchatton Chapel, lichen growing prolifically in the clean air

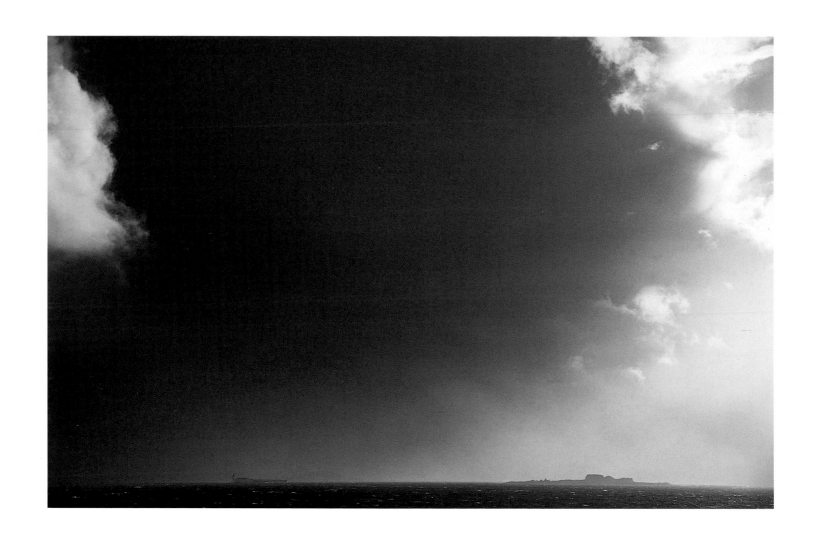

An approaching storm over the Garvellachs, viewed from Cullipool

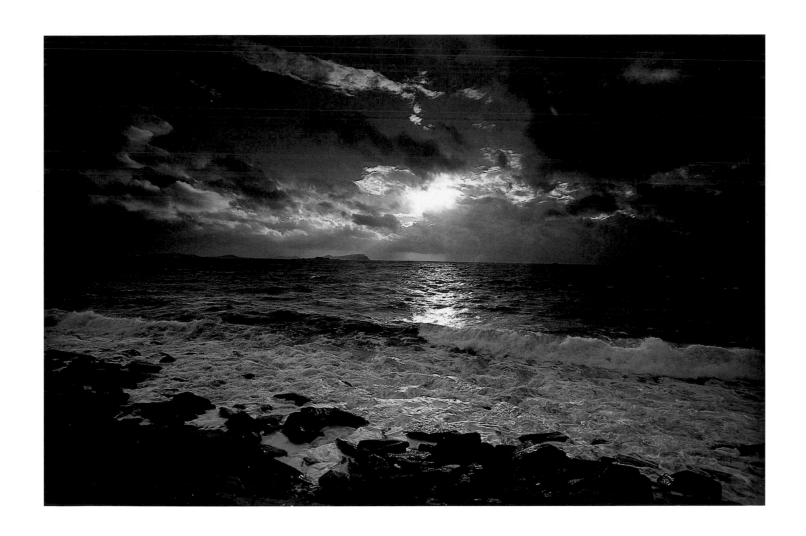

Wild light over the Firth of Lorne from Cullipool

Curious quartz formation in a slate boulder, Cullipool beach

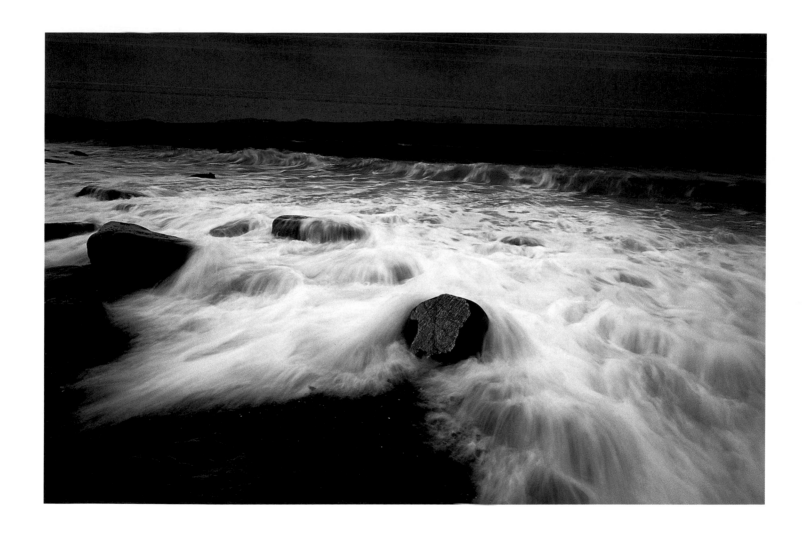

Foul and dark stormy morning near Cullipool, with surf crashing around a quartz patterned boulder on Rubha Buidhe

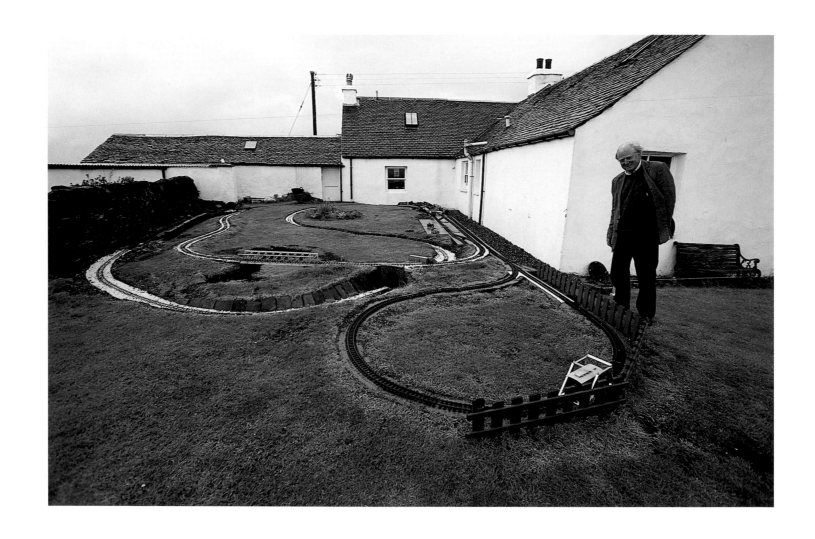

Cullipool resident Nigel Dyckhoff, a lifelong railway enthusiast, with his model railway in his garden, "The Isle of Luing Railway Co."

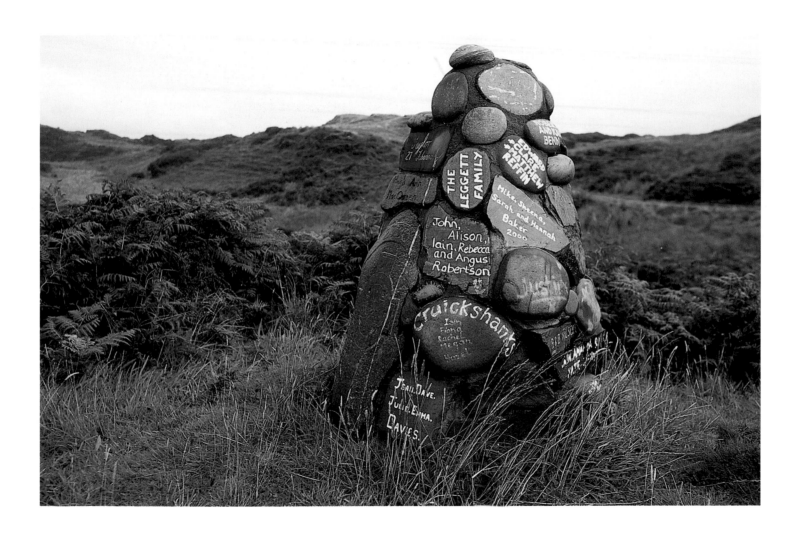

Cairn at the crossroads, with island residents names painted on the rocks for the millennium

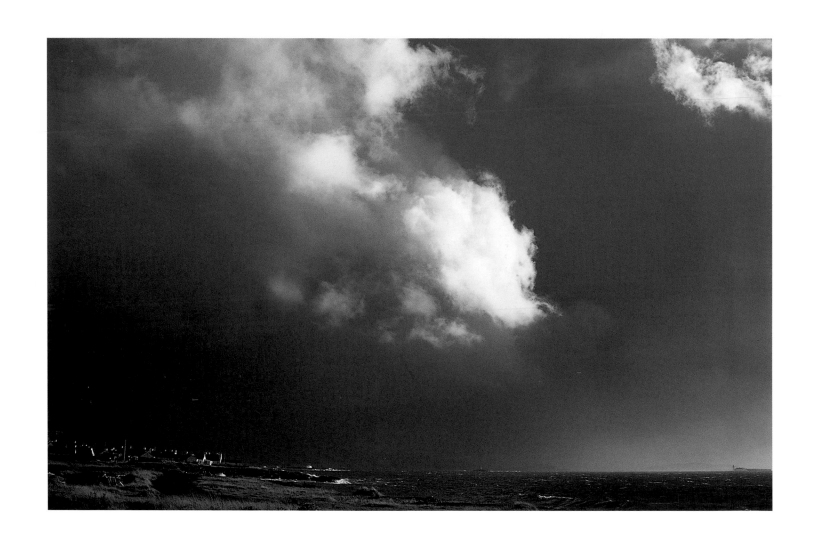

Cullipool village in afternoon light as a storm approaches

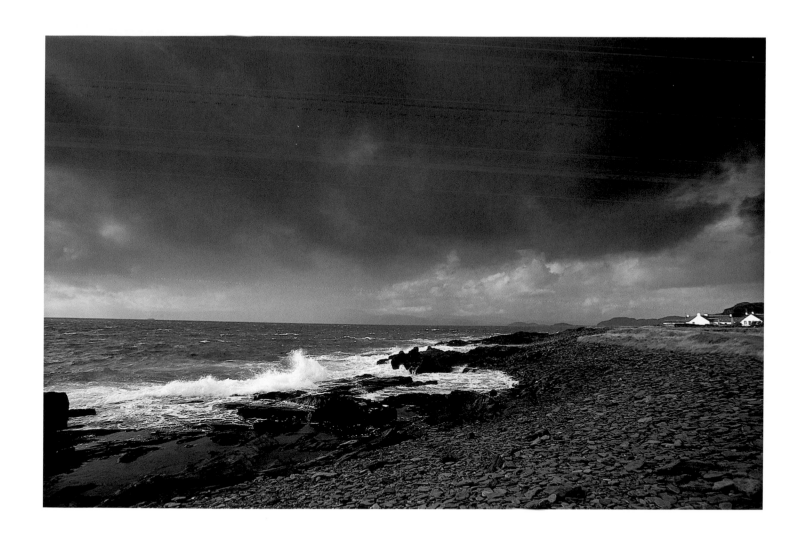

Dark sky over a slate pebble beach near Cullipool

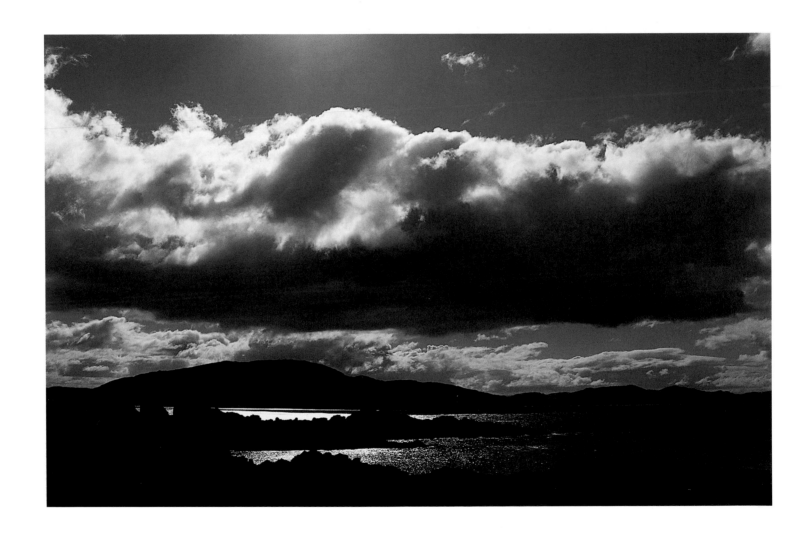

View across to Scarba and Jura on the eastern horizon

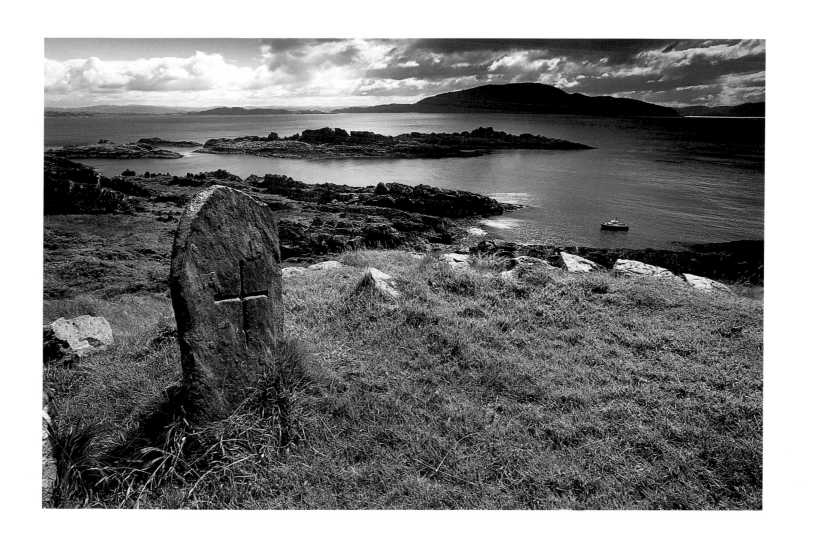

Eithne, Princess of Leinster, and mother of St Columba is reputed to be buried here, the small slate slab with incised cross marking the spot

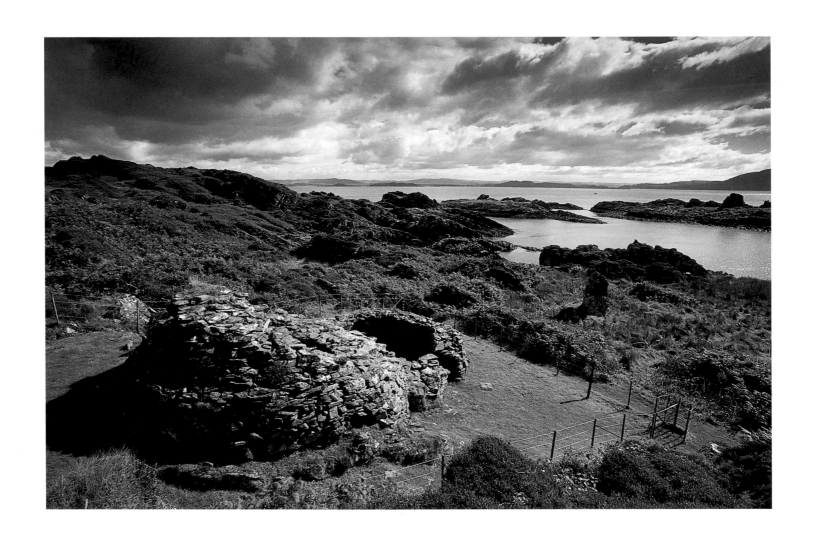

A beehive cell, one of the finest examples in Scotland

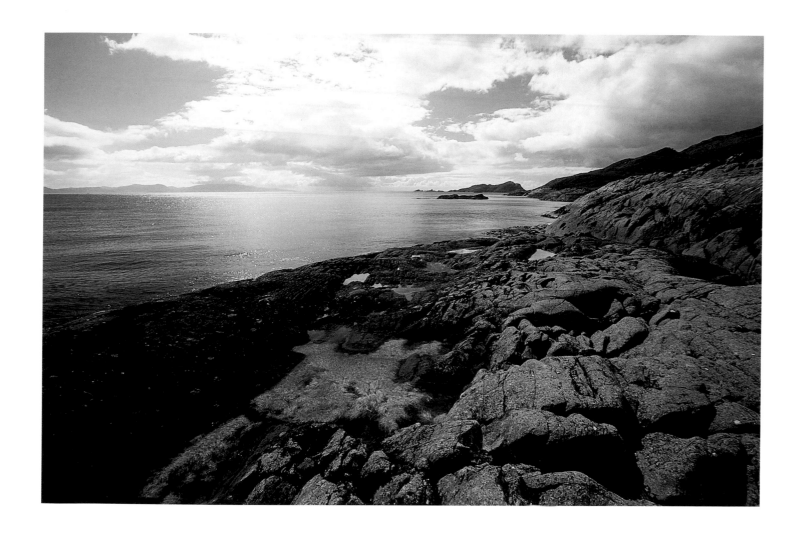

View south along the line of islands

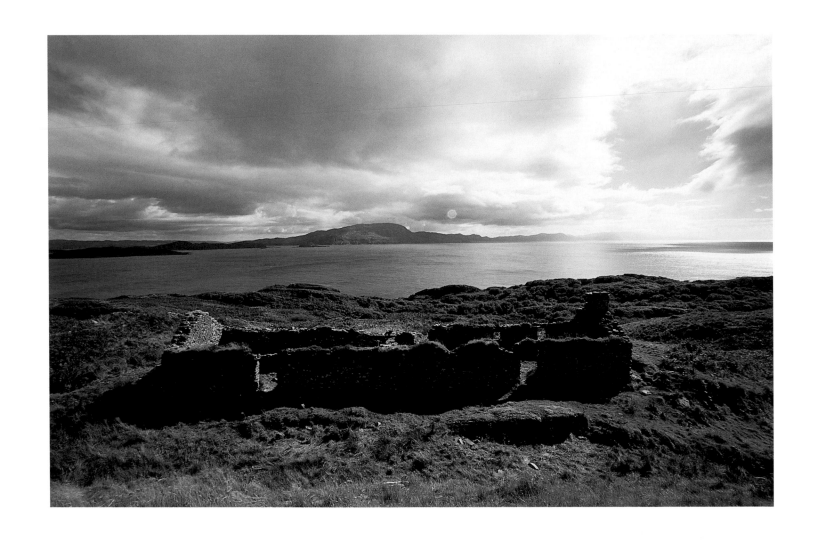

From high on the side of the island the view from this ruined cottage is stunning, nothing but islands, islands, islands as far as you can see!

The cottage at Rubha Mor

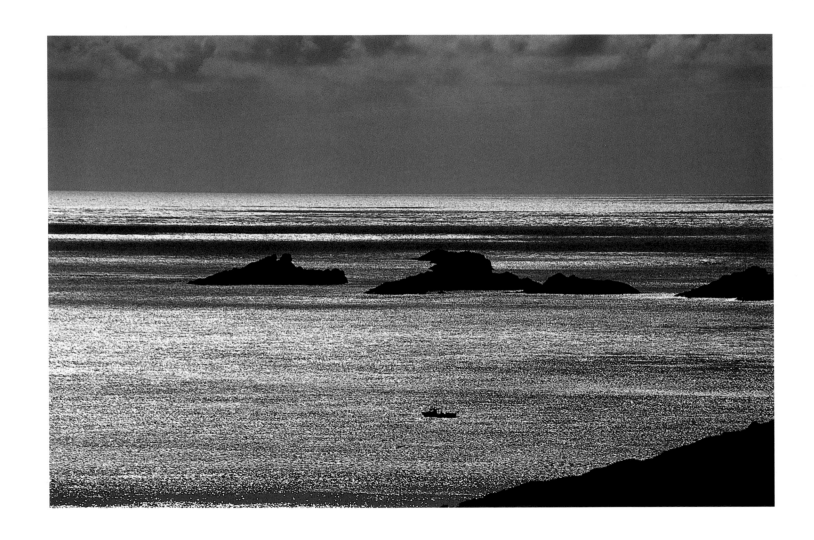

A fishing boat in a sunsparkled sea with the skerries off Eileach an Naoimh behind

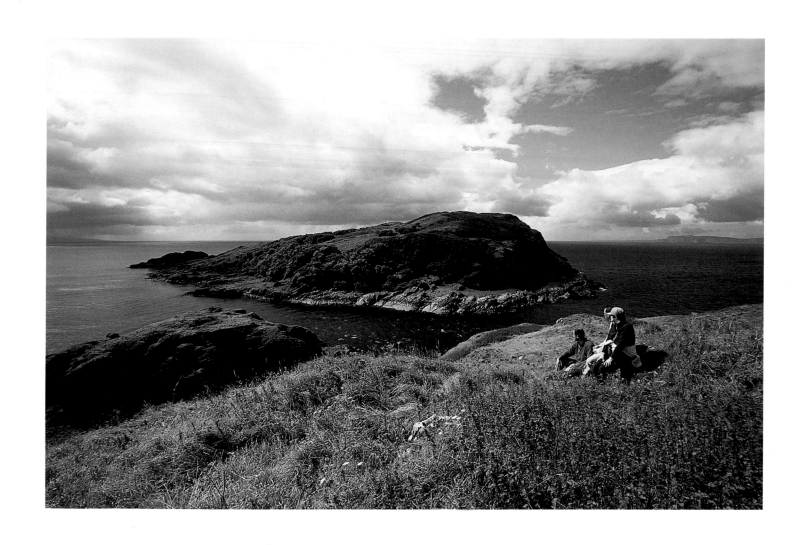

My companions looking towards the east end of Garbh Eileach

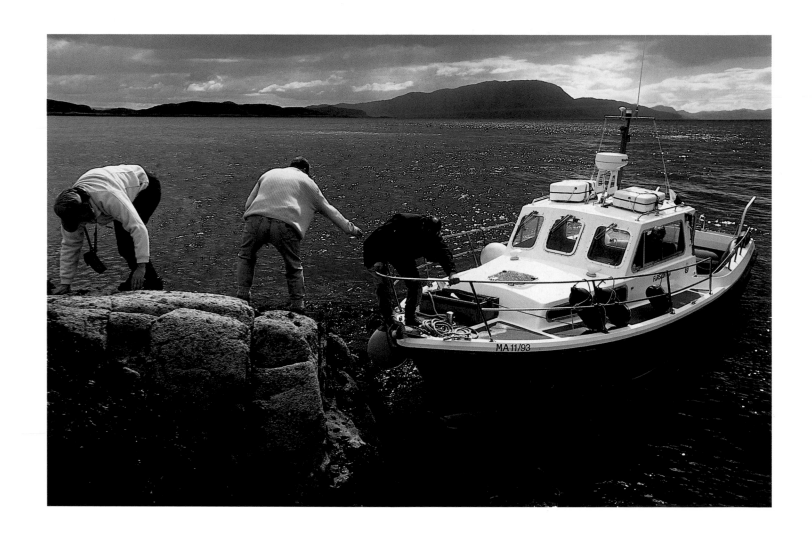

A typical landing scenario as my companions try to judge the swell before committing themselves to half the challenge of remote island landings, with 'The Shorewards Leap'

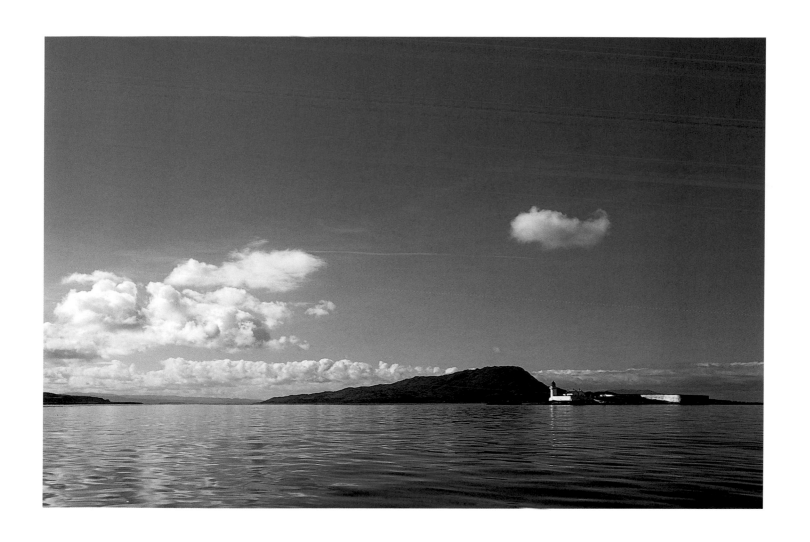

The lighthouse on Fladda with the Garvellachs behind

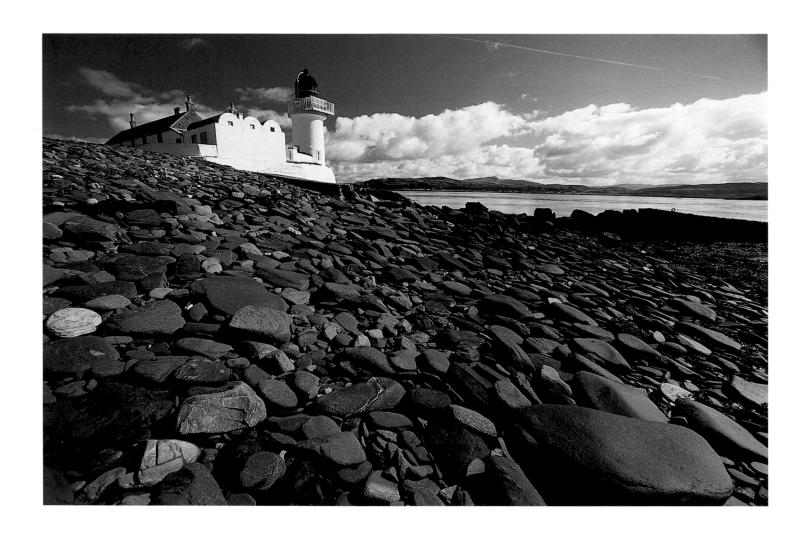

The slate beach and lighthouse

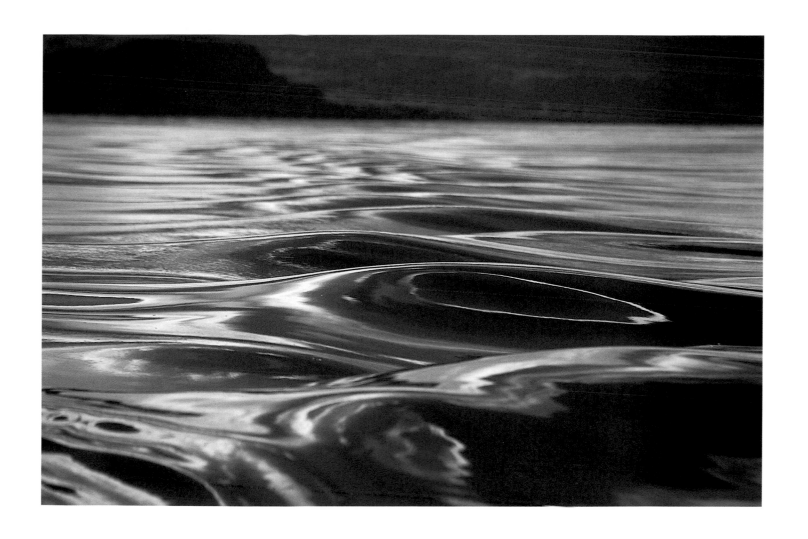

A limpid sea as we leave Craobh Haven for the Isles of The Sea

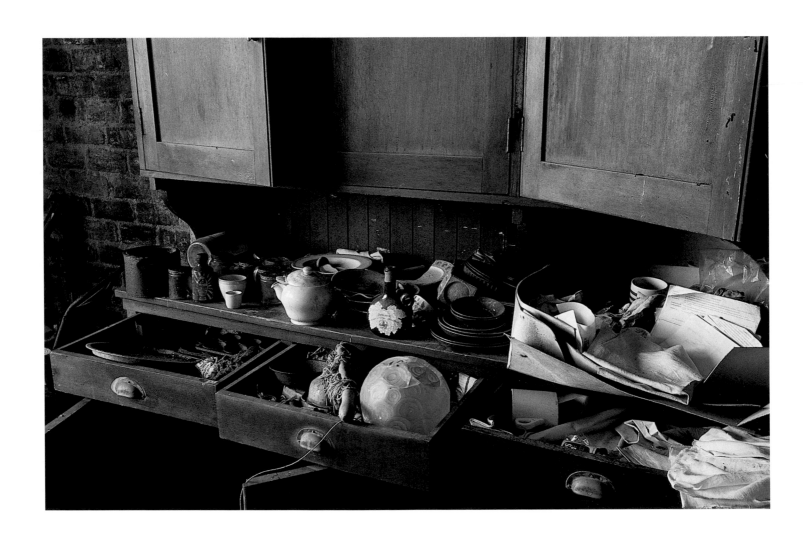

The evocative crumbling interior of Shuna House

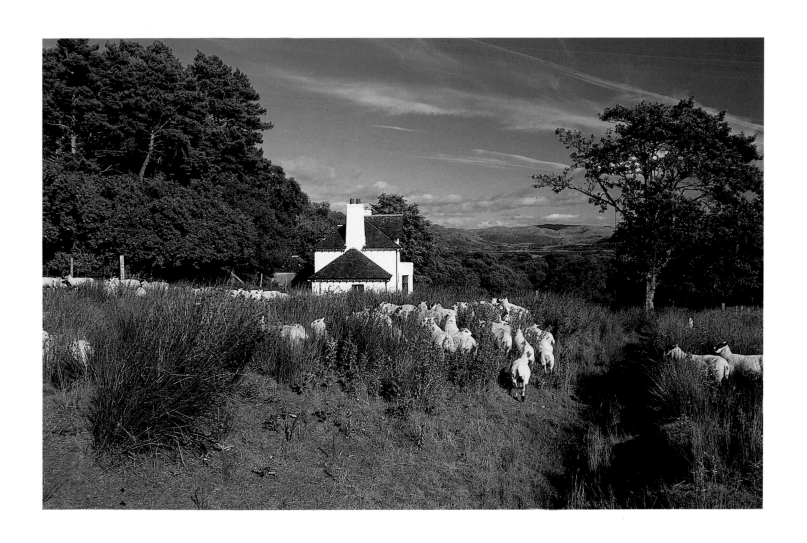

Cottage and sheep near Shuna House

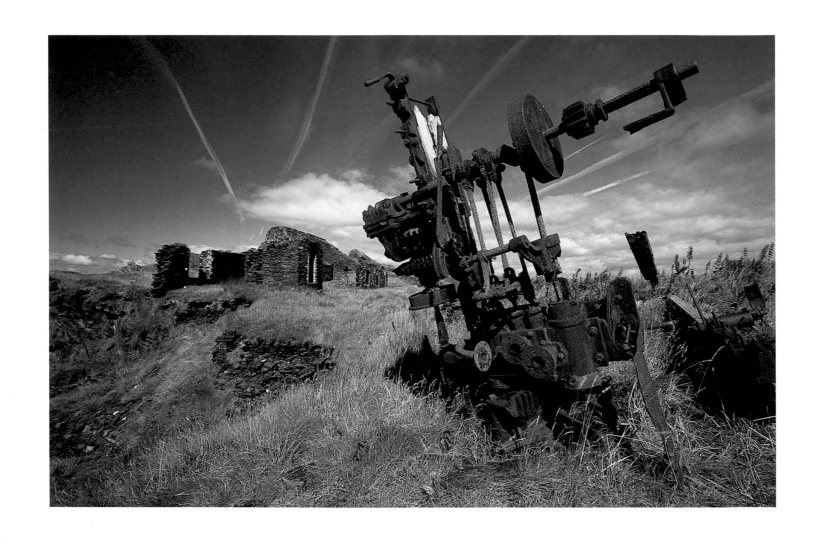

Ruined machinery and crumbling cottages with the vapour trails of jets making the Atlantic crossing above

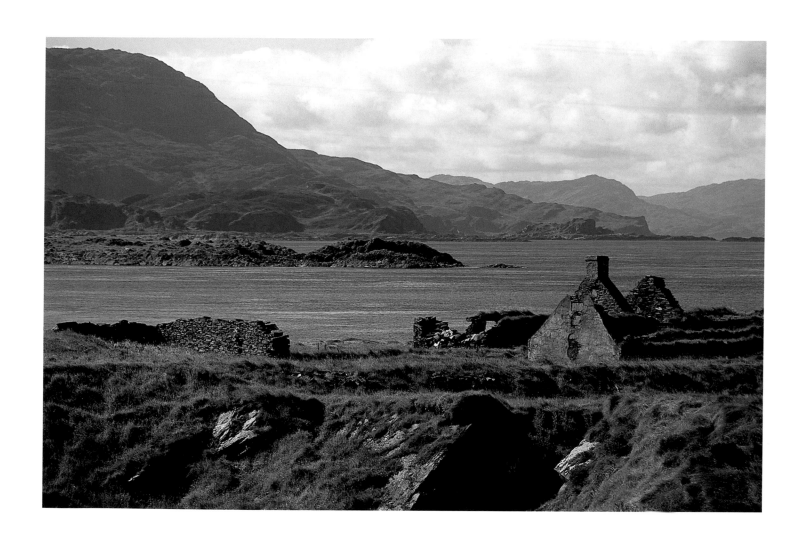

The ruins of the slate workers houses and the Garvellach Islands behind

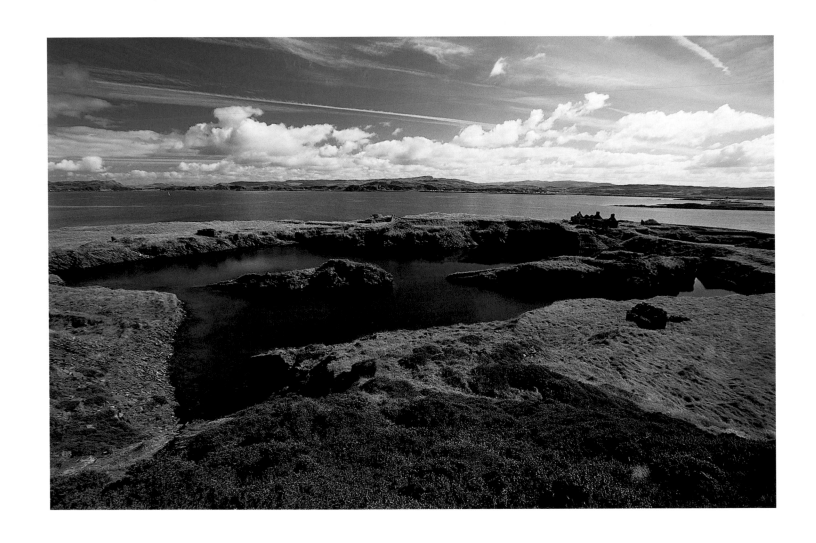

The slate quarriers removed the centre of the island

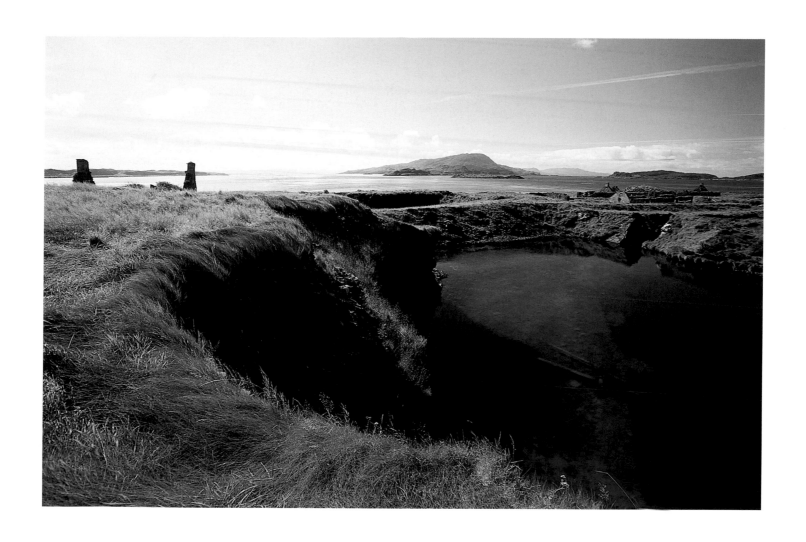

The quarry filled with crystalline water, with the remains of equipment visible far below the surface

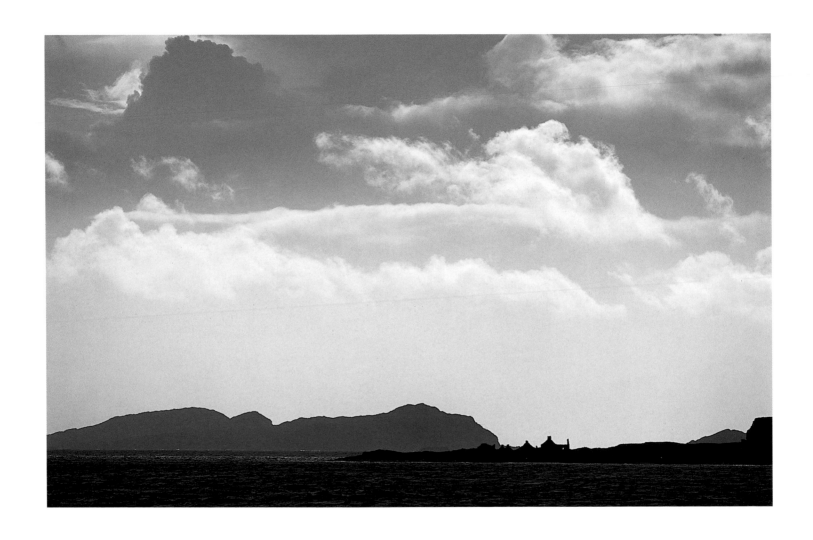

Ruined buildings on Belnahua, with the Garvellach Islands visible behind (viewed from Cullipool, Luing)

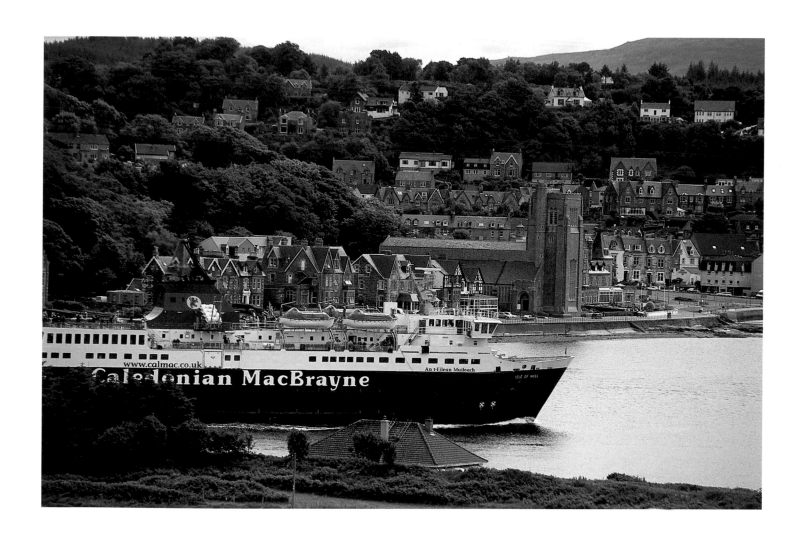

Caledonian MacBrayne Ferry, entering Oban Bay

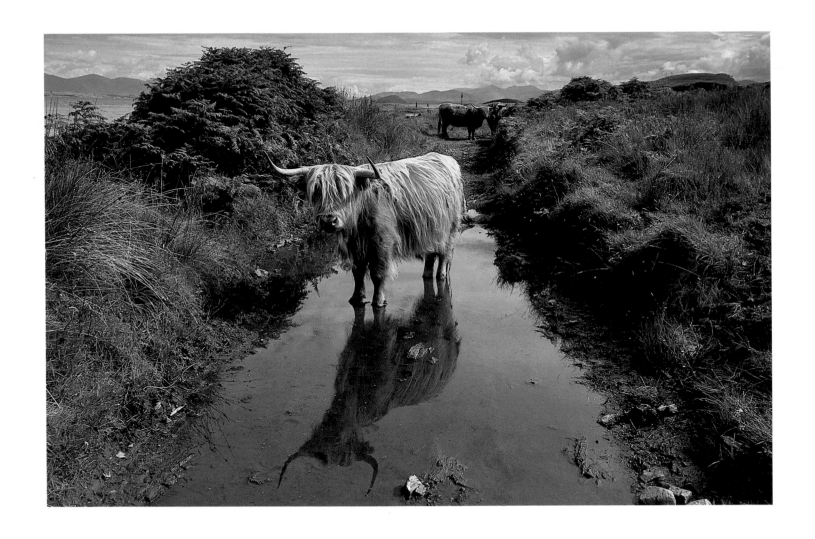

Cattle, Oitir Mhor

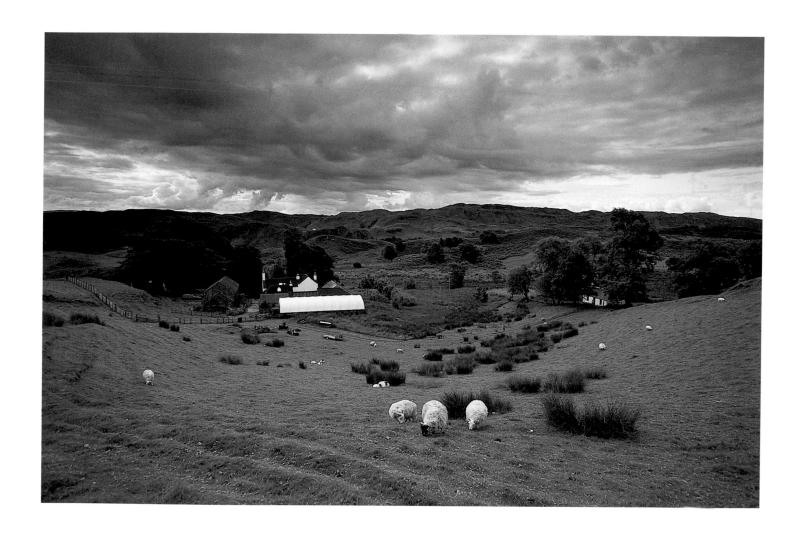

Farm, Ballimore, with the mainland behind

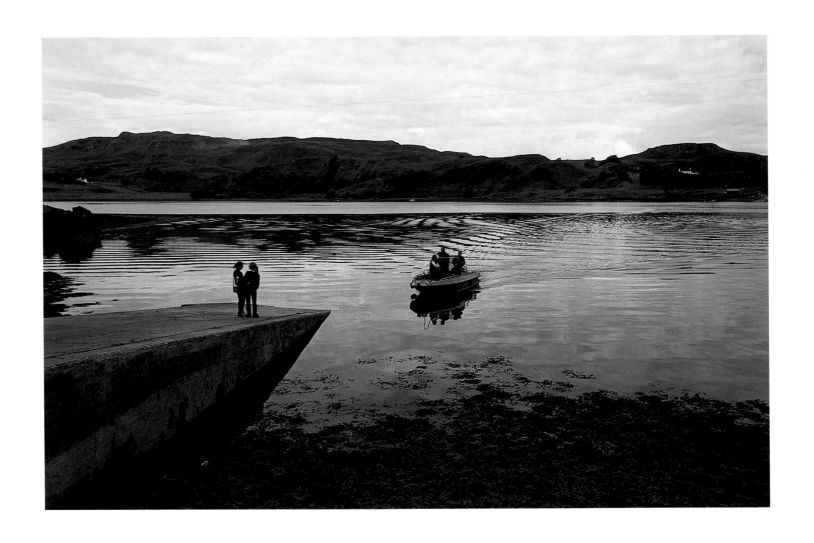

Ferry to Kerrera, Galanach near Oban

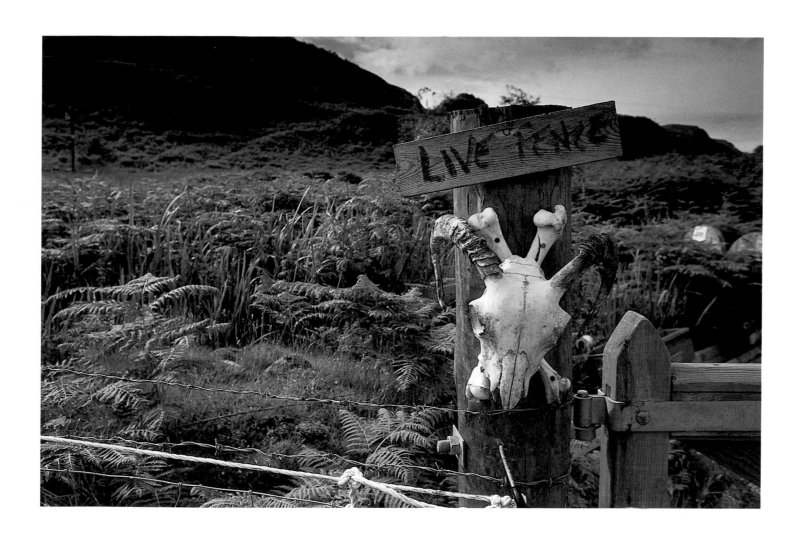

Warning sign and electric fence, an unwelcoming feature in an otherwise soft and gently lush landscape, Oitir Mhor

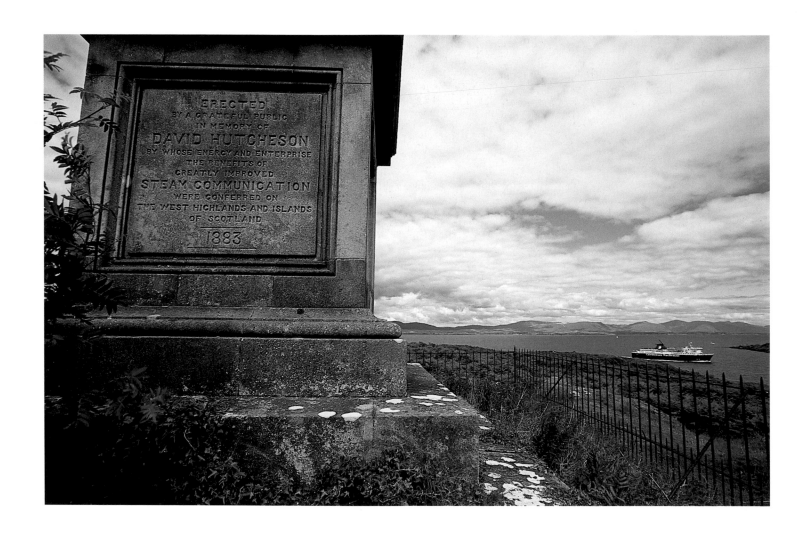

The inscription reads:

ERECTED
BY A GRATEFUL PUBLIC
IN MEMORY OF
DAVID HUTCHESON
BY WHOSE ENERGY AND ENTERPRISE
THE BENEFITS OF
GREATLY IMPROVED
STEAM COMMUNICATION
WERE CONFERRED ON
THE WEST HIGHLANDS AND ISLANDS
OF SCOTLAND
1883

Memorial to David Hutcheson, one of the founders of the Caledonian MacBraynes ferries, above Ardantrive Bay

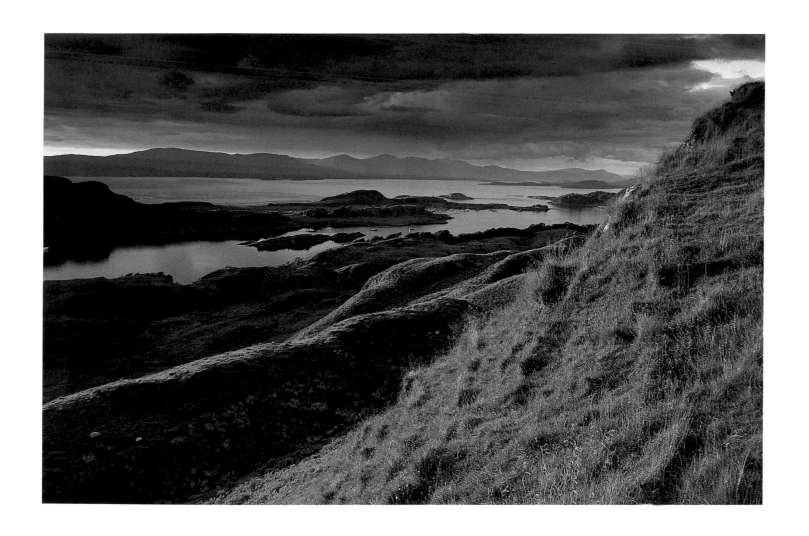

Sunset over Kerrera with Lismore visible, and the Kingairloch hills behind

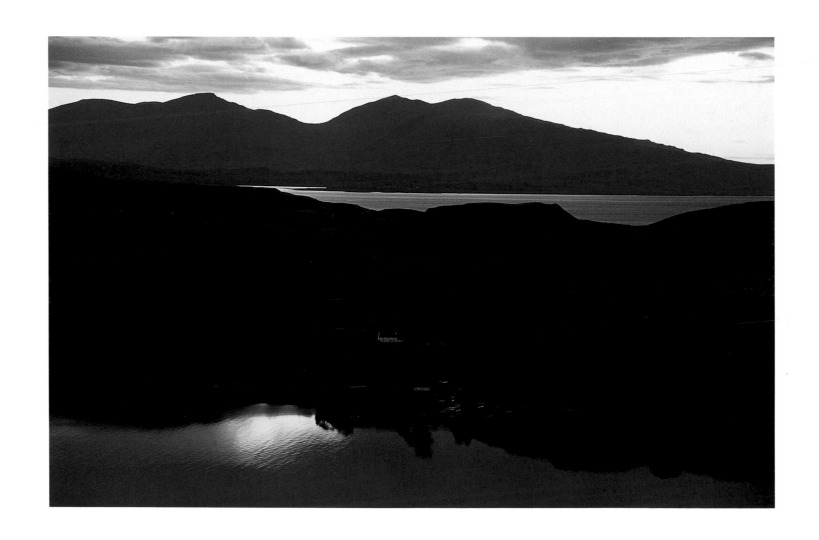

Sunset over Kerrera, Lismore just visible, and the hills of Kingairloch behind

Old fence & gate detail near Port Ramsay

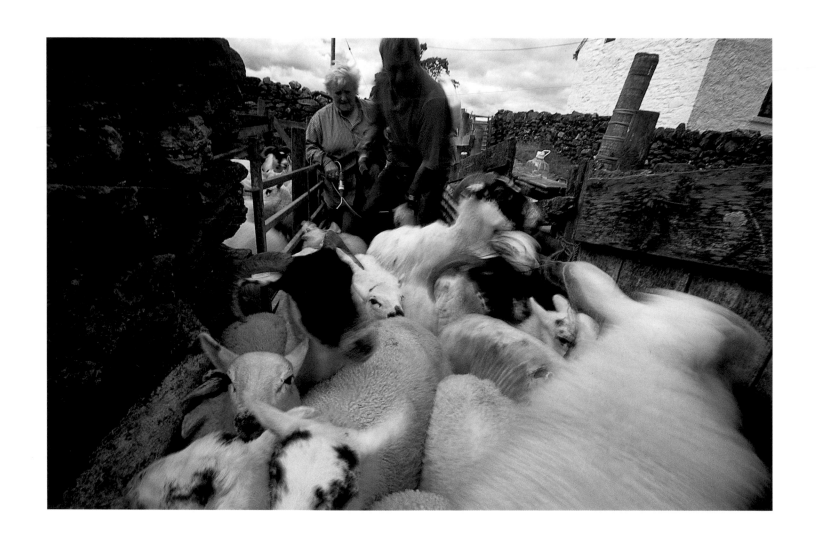

Iris McColl & son-in-law, Peter Walker, working the sheep at Achinduin

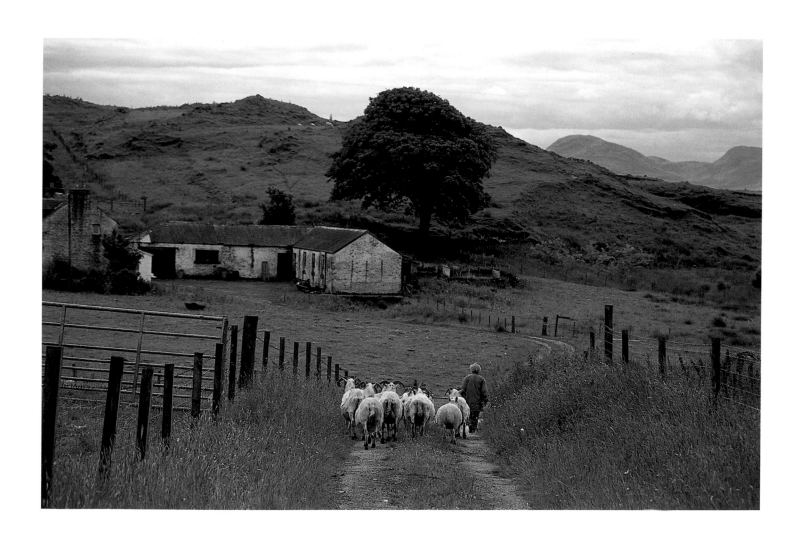

Iris McColl herding her flock, Achinduin

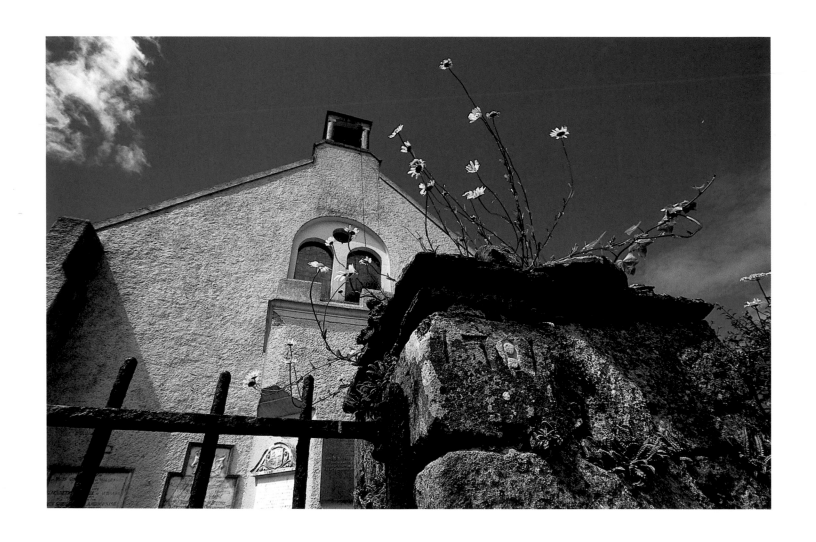

Date incised in stone, gate of St Moluag's Church at Clachan

One of the fine stained glass windows in St Moluag's Church

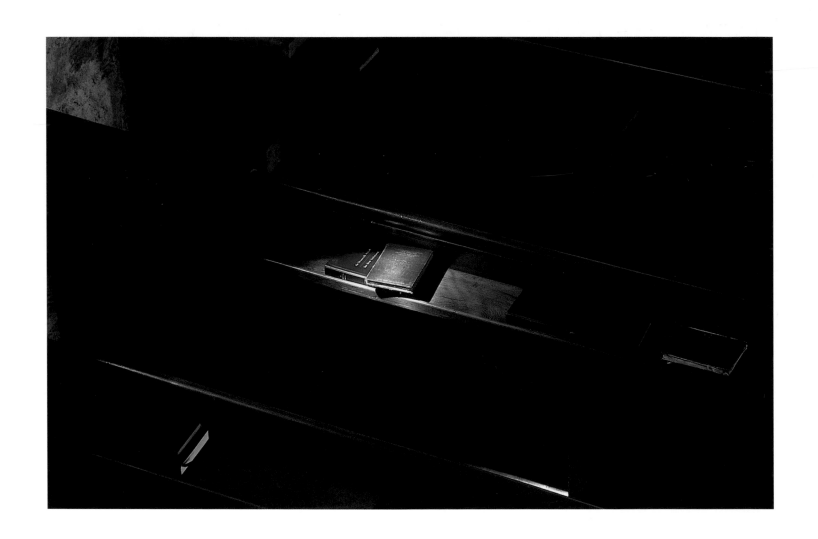

A shaft of sun bathes a hymn book in warm afternoon light

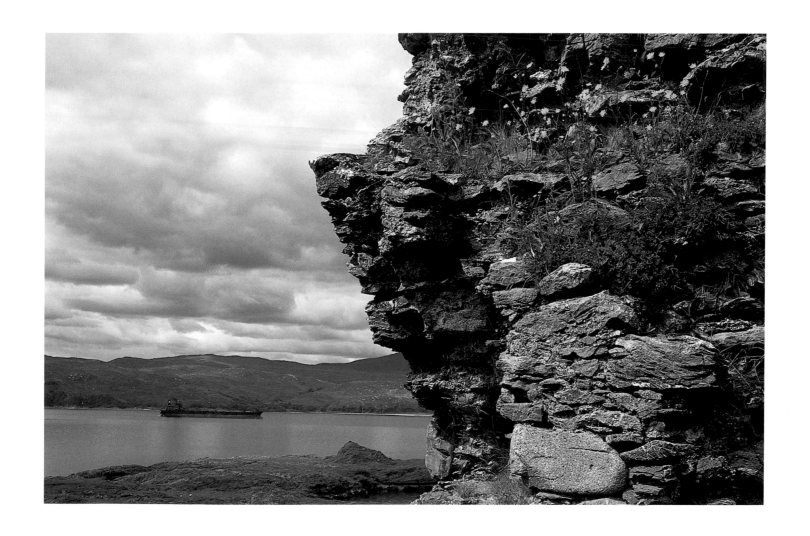

An ore carrier heading to Glensanda superquarry to pick up a load destined for road building, contrasts with the older use of stone in the walls of Achadun Castle

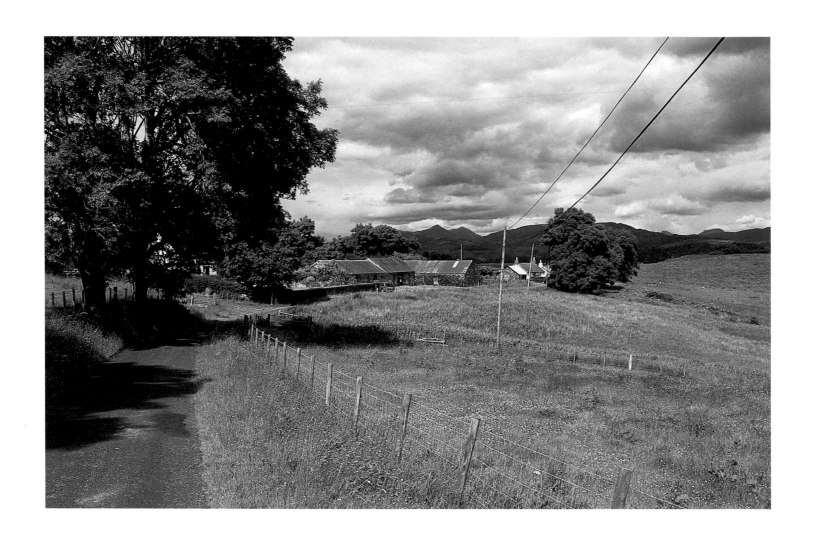

Rusting corrugated roofs at Clachan punctuate a tranquil summer landscape

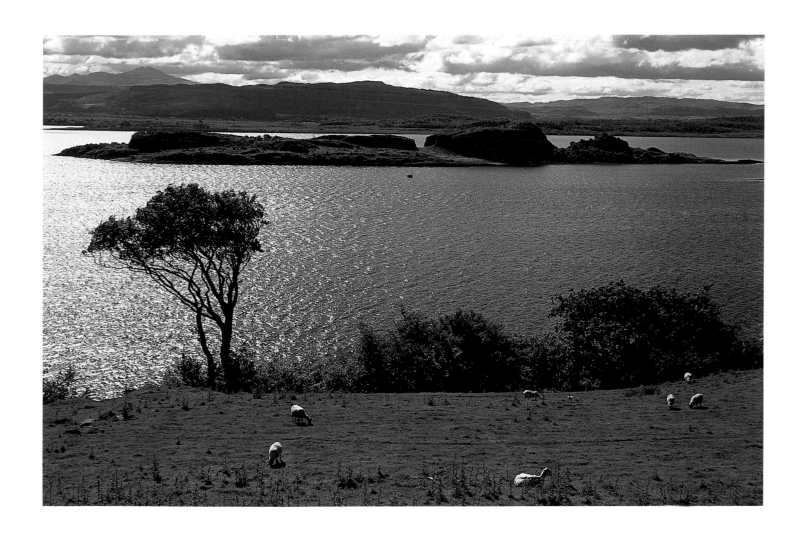

A fishing boat working off Eilean Dubh, from Tirefour Castle

The old boiler behind the Shark Station slowly dissolving in the salty air, with the vivid green of bracken showing through

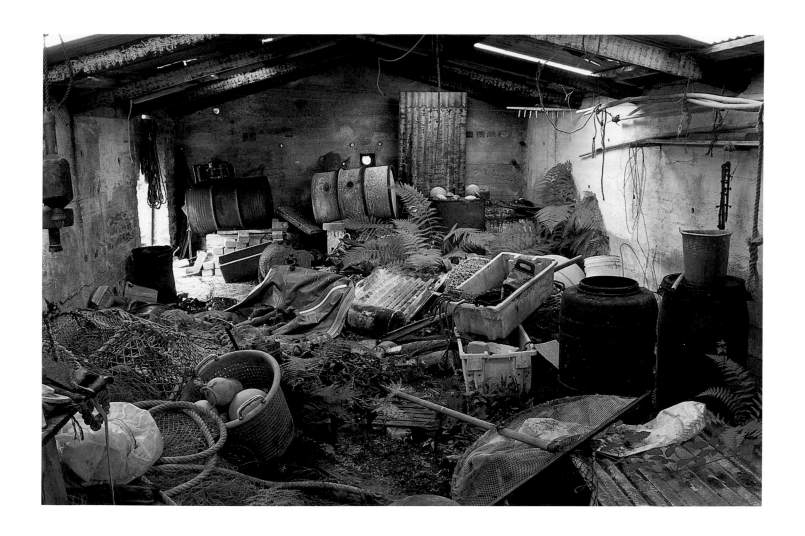

One of Gavin Maxwell's old buildings now used as a Fisherman's Store and full of a wonderful collection of 'stuff'

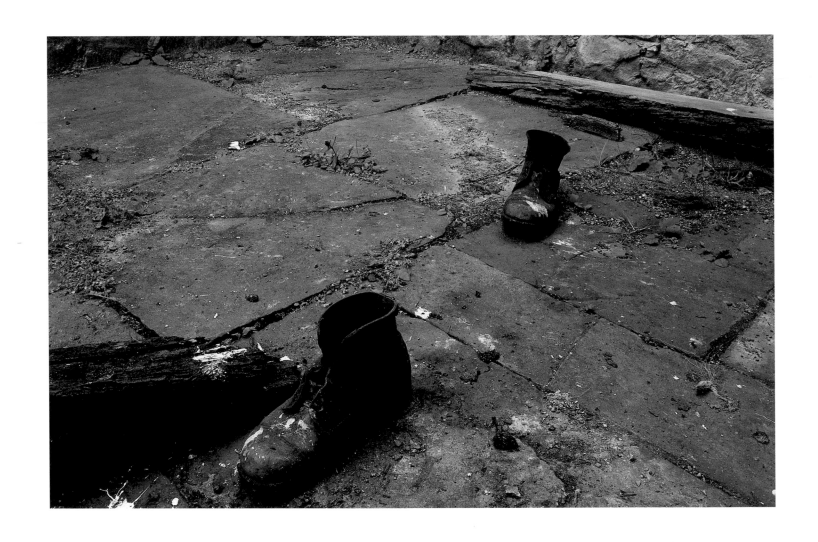

A pair of old boots in Soay Shark Station, moss covered and spattered with birdlime, an evocative reminder of previous inhabitants, and lying exactly as we found them

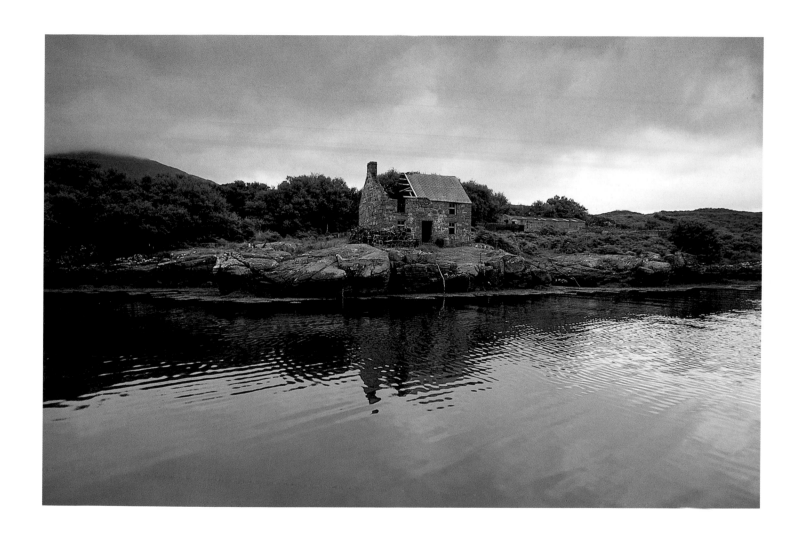

The Shark Fishing Station viewed from Soay Harbour

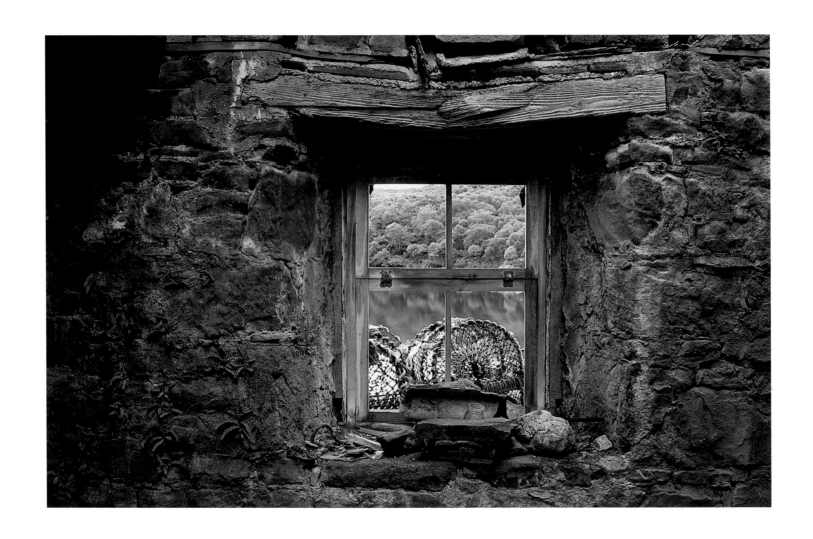

A crumbling window frame looks out onto Soay Harbour

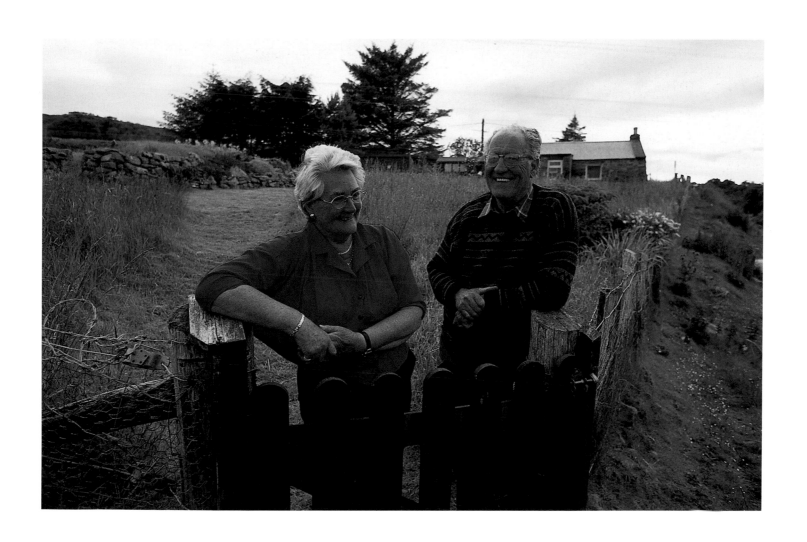

Tex Geddes' niece Jan Lovett and her husband Ian own one of the cottages on the island and live there for a large part of the year

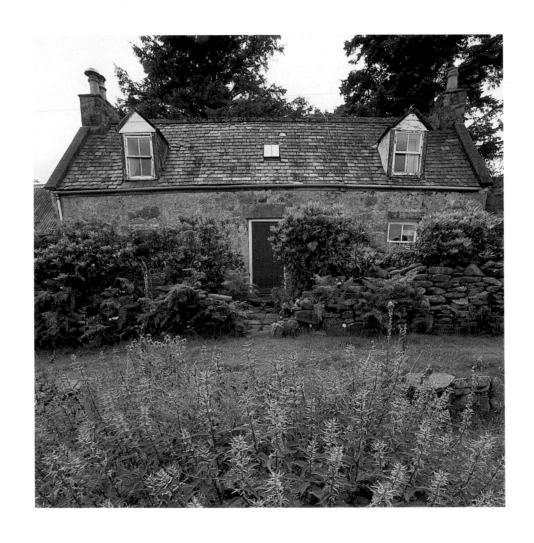

Nettles and empty cottage at Mol-chlach (G. 'village by the pebble beach')

Bladderwrack seaweed at Mol-chlach

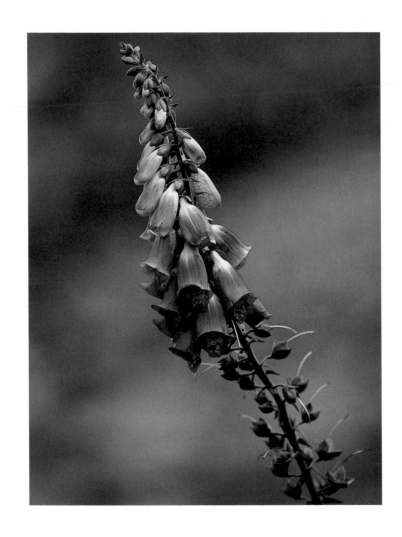

Foxglove, Mol-chlach

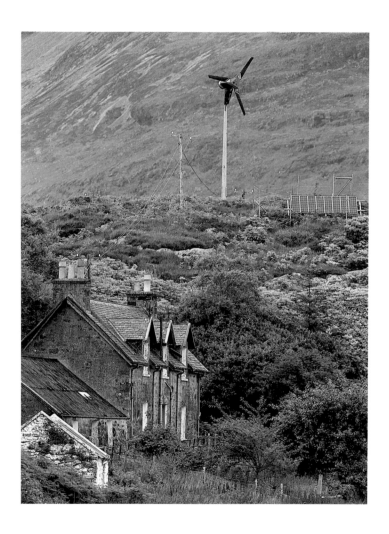

The world's first solar-powered telephone exchange above Mol-chlach, with the bulk of the Cuillin Mountains on Skye looming behind

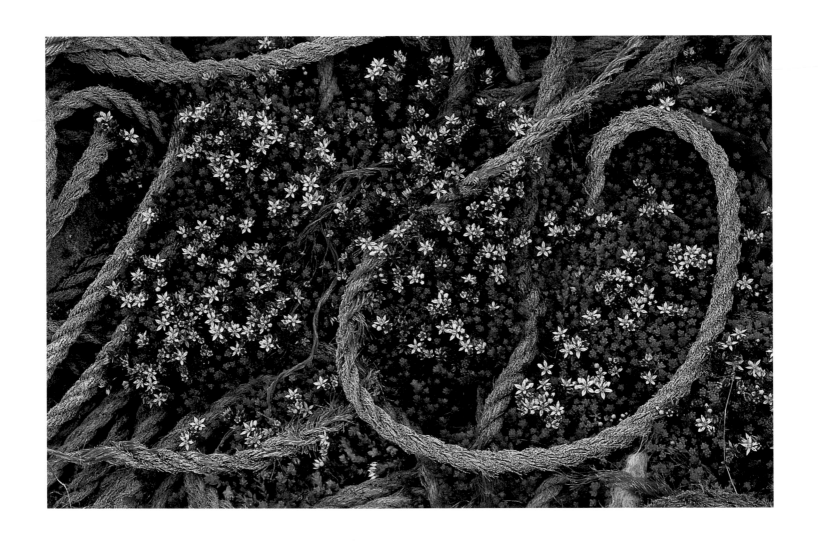

Washed up nylon rope and White Stonecrop on the shore, Mol-chlach

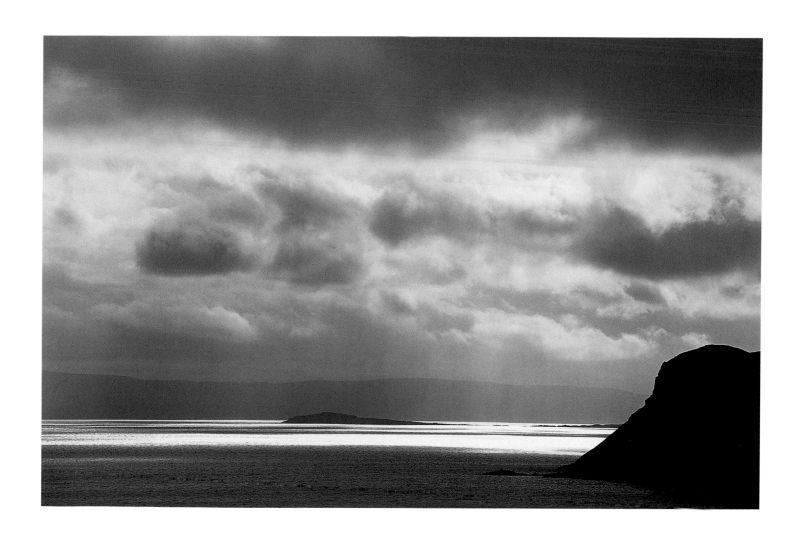

Ascrib Islands and Loch Snizort in dramatic light, viewed from Uig on Skye

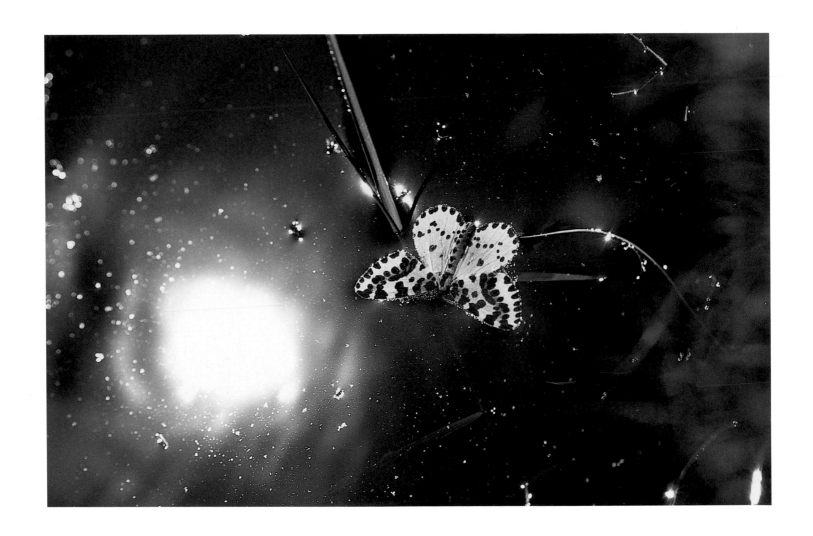

Magpie moth in a small pool on the rocks, South Ascrib

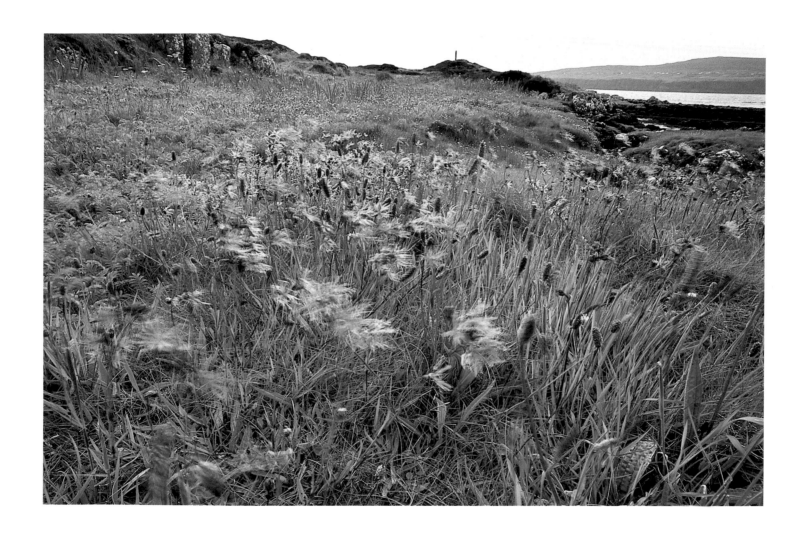

Ragged Robin blowing in the wind, South Ascrib

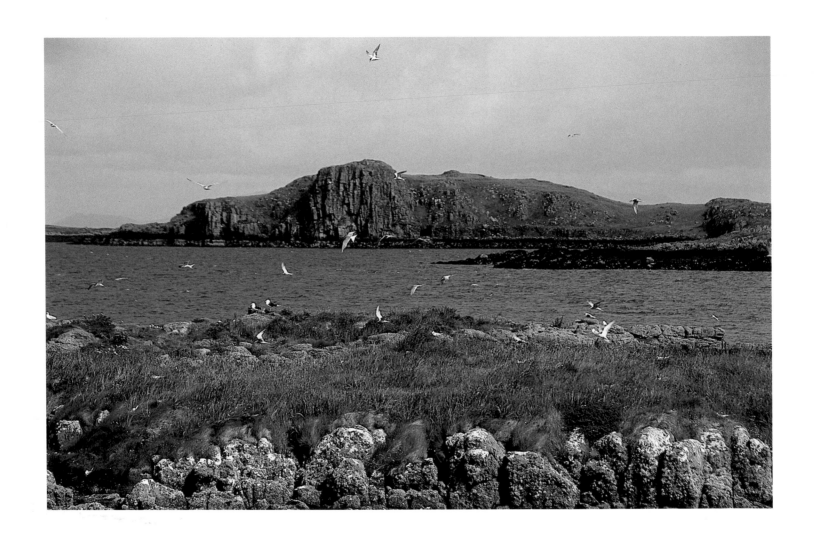

View north across the Ascrib Islands, from South Ascrib

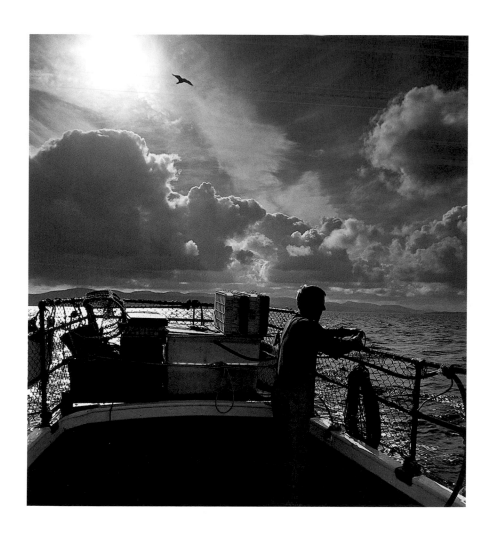

Paddy Smith prepares the gear on Pete Naylor's boat in Loch Snizort

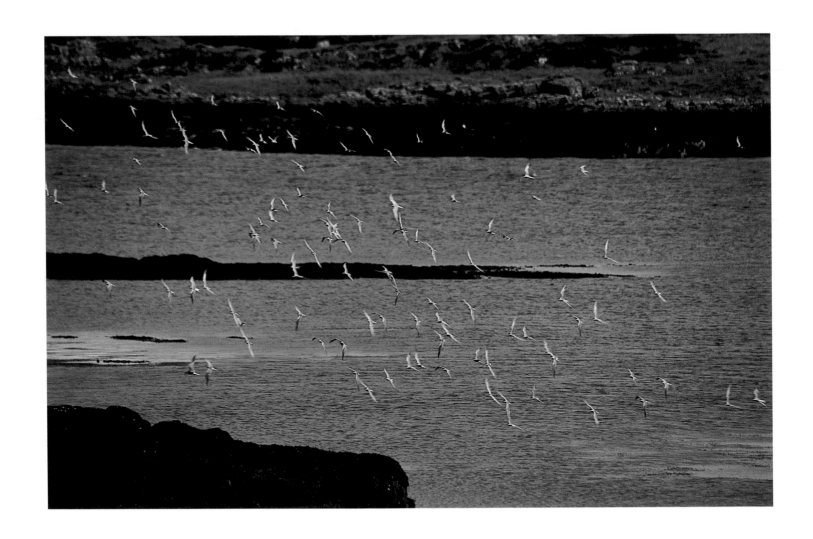

Tern colony raucously wheeling above the bay, South Ascrib

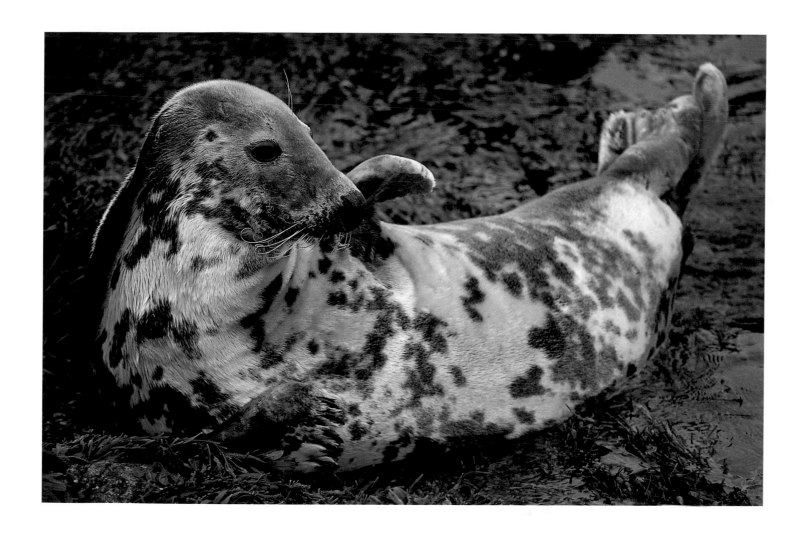

Atlantic Grey seal relaxing on the rocks, South Ascrib

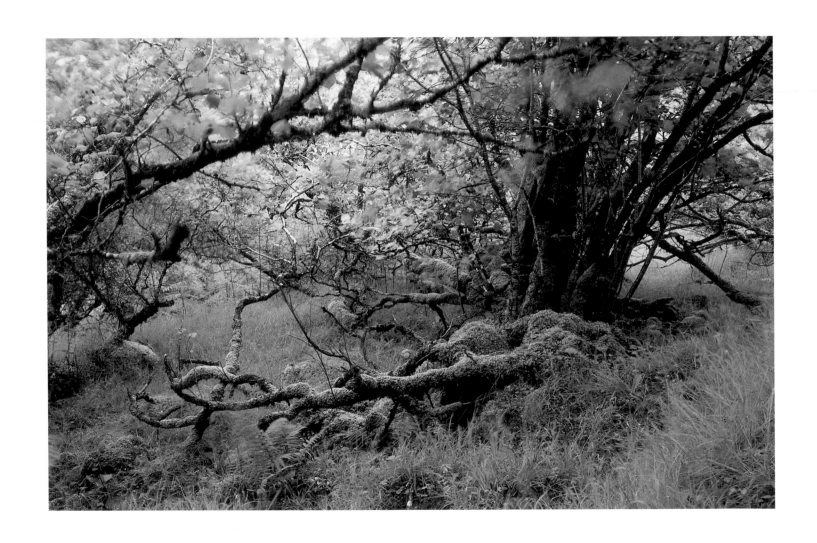

Old coppiced hazel woodland beside the path at Hallaig, evidence of the community that once managed this landscape

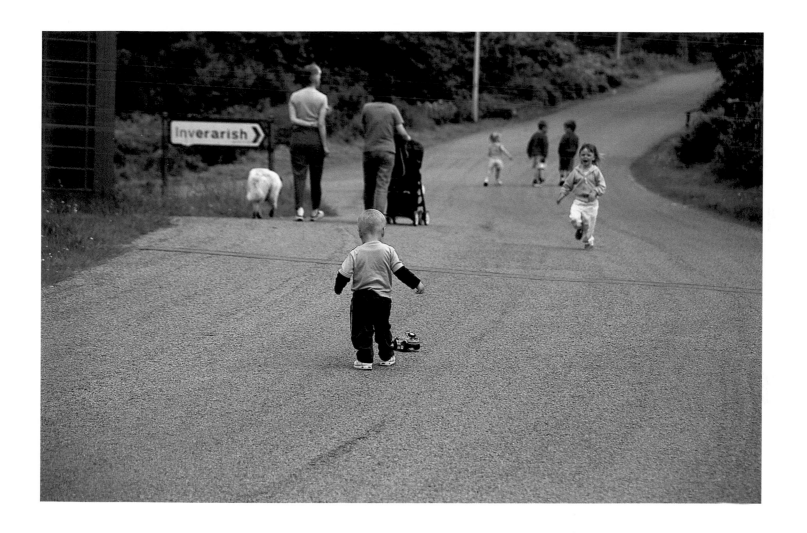

A family out for a stroll on the road near Inverarish

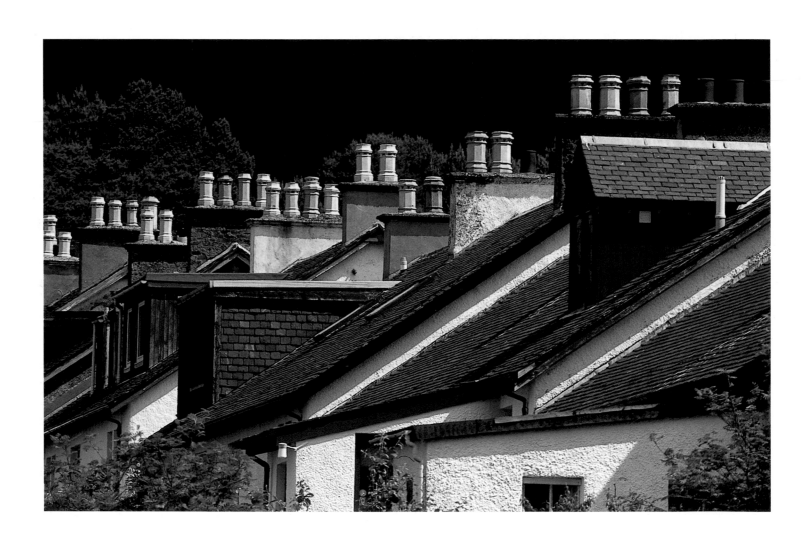

Line of chimneys on the cottages, Inverarish

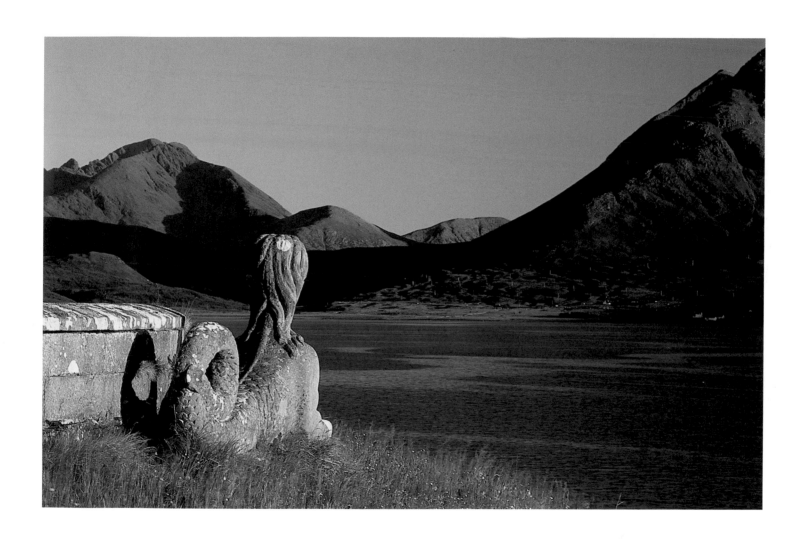

One of two mermaids at the Battery overlooking Churchton Bay, with Sconser on Skye behind

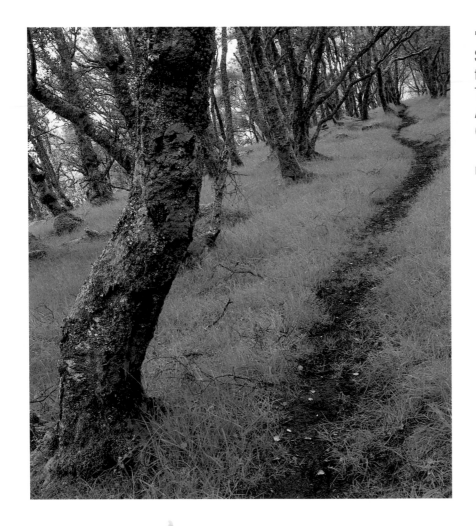

"The girls a wood of birch trees,
Standing tall with their heads bowed... Between the Leac and Fearns
The Road is plush with moss
And the girls in a noiseless procession
Going to Clachan as always"

FROM THE POEM 'HALLAIG' BY SORLEY MACLEAN

Path through the woods, Hallaig

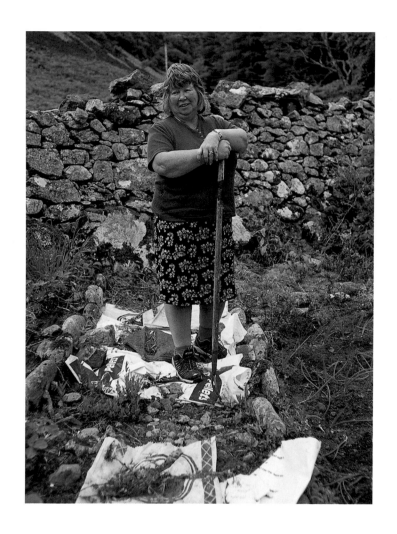

Raasay native Rebecca MacKay working in her garden, Oskaig

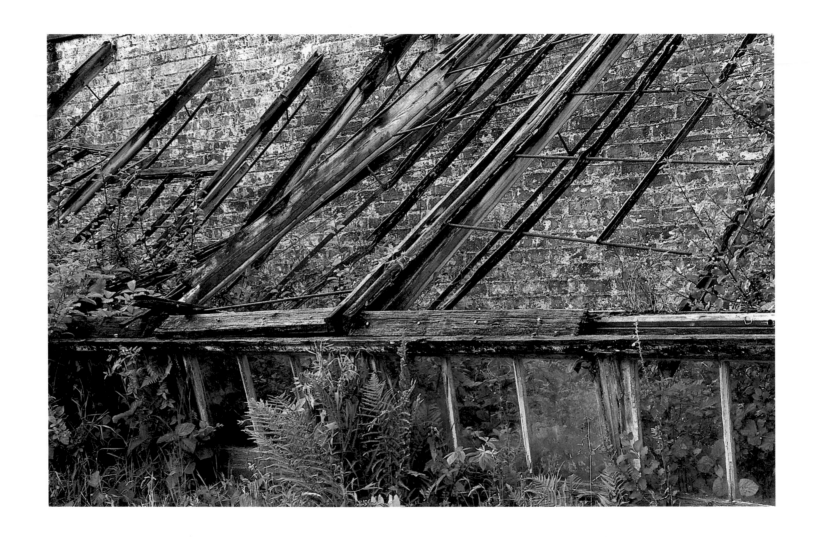

The crumbling frames of greenhouses in the gardens behind Raasay House

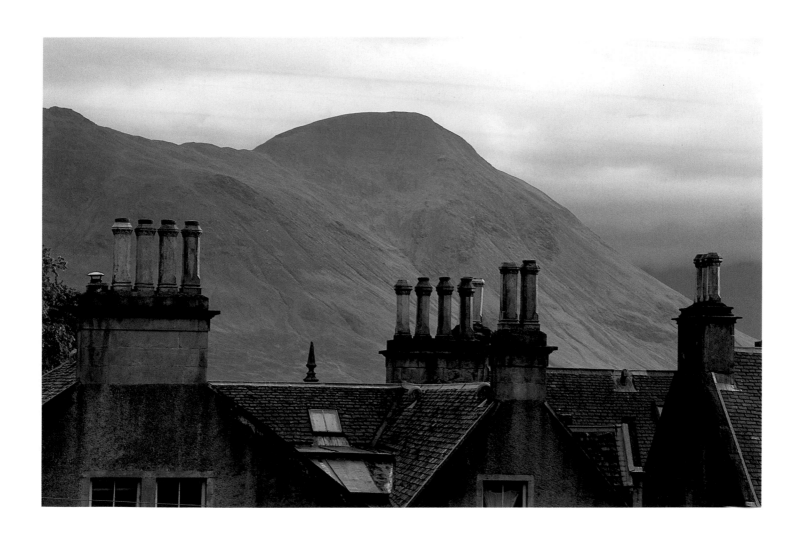

The chimneys of Raasay House against the Red Cuillin on Skye behind

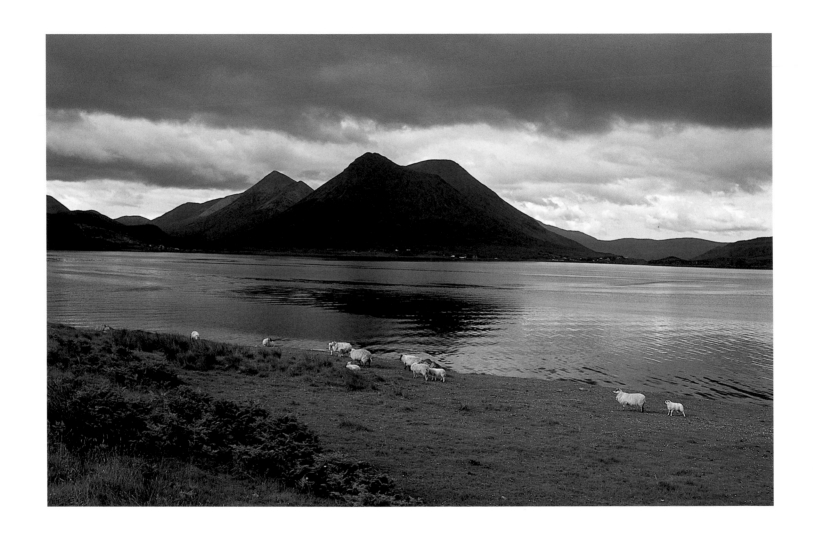

View across the Sound of Raasay to Sconser and the Red Cuillin

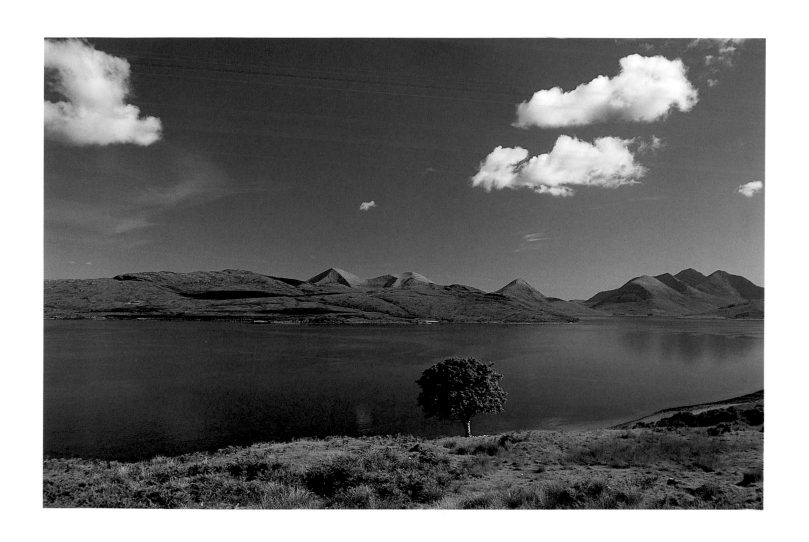

A day of crystalline light at Fearns, looking towards Scalpay and the Red Cuillin

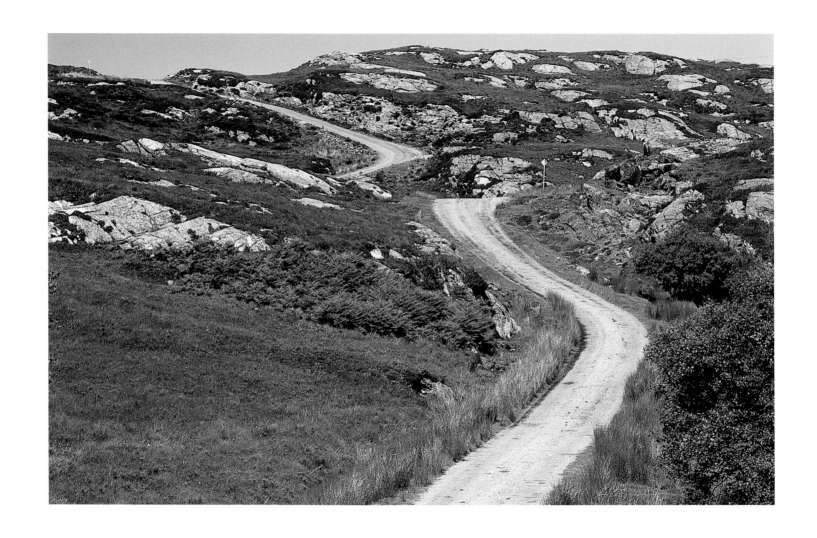

Calum's Road, running 2.5 km from Brochel to Arnish, built by Calum MacLeod, a postman, using only a pick. It took him almost 10 years. He was awarded the BEM for his efforts, but sadly Calum died soon after finishing.

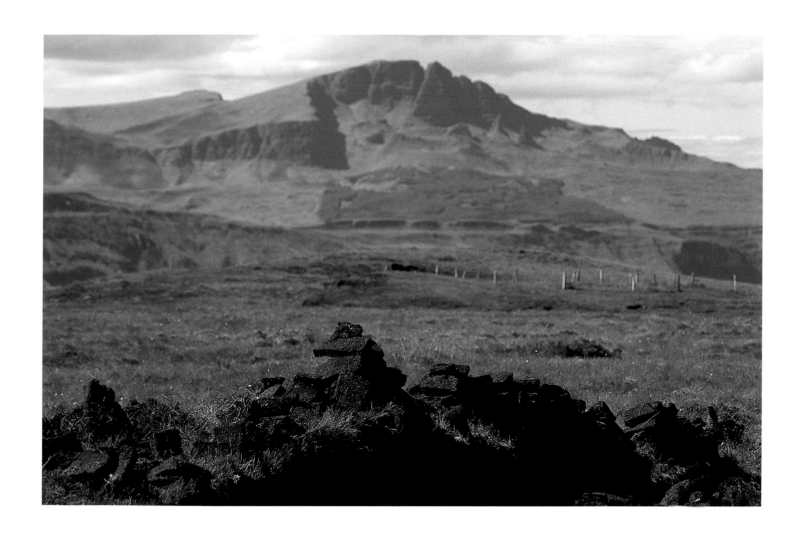

Stacked peats on the hillside near Glame, with the Skye hills behind

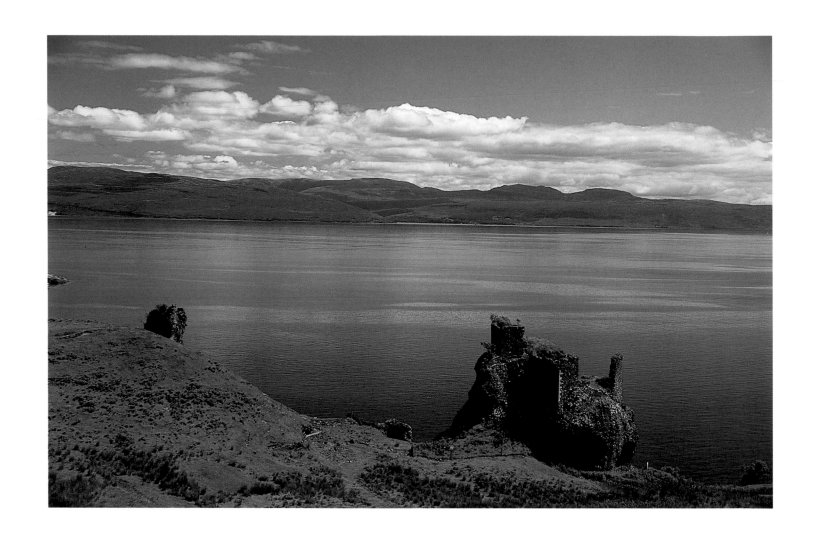

Brochel Castle, built by the MacSwans in the 15th century, with Applecross Peninsula behind

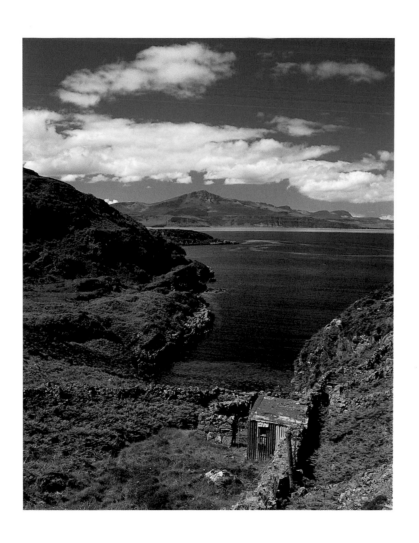

View to Skye from Calum's Road, beside Loch Arnish

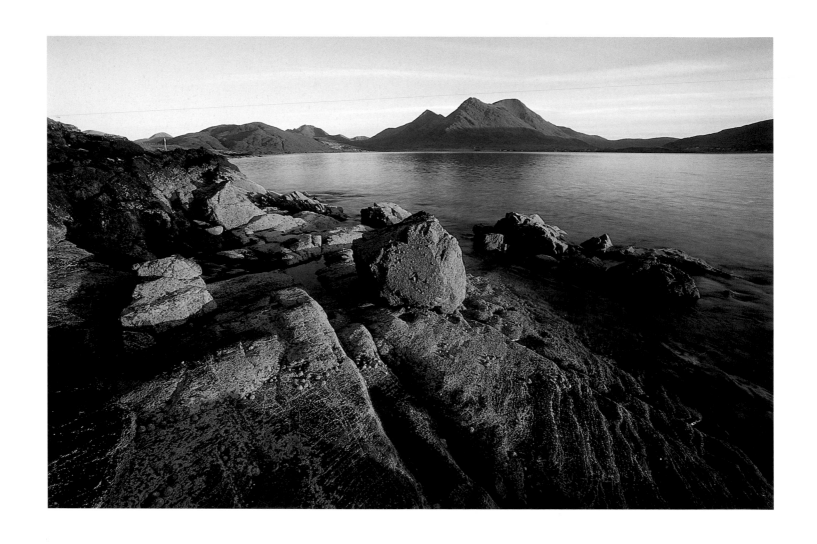

Sconser & the Red Cuillin in evening light from the shore near Inverarish

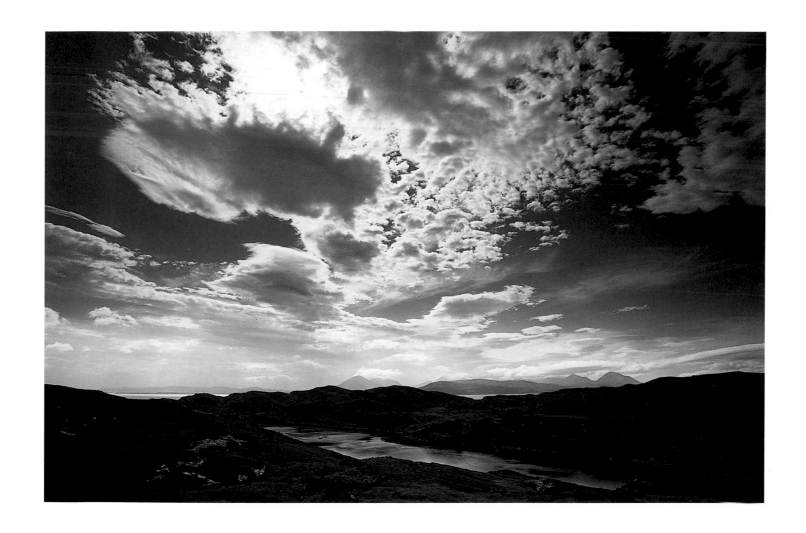

Crowlin Harbour, a natural feature between Eilean Meadhonach and Eilean Mor, Skye Cuillin in background

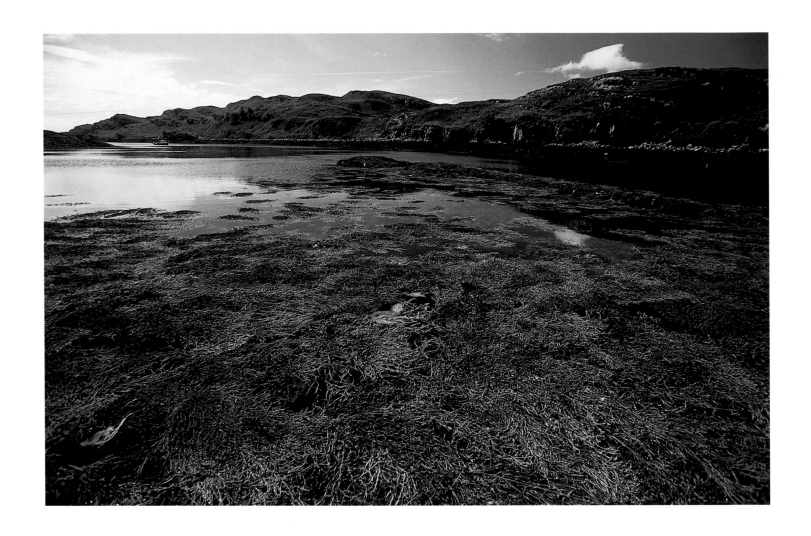

Crowlin Harbour

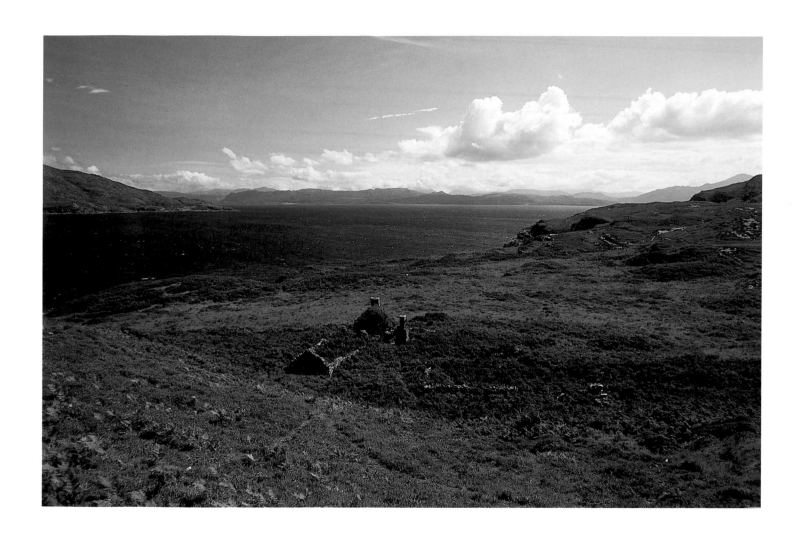

East Coast of Eilean Mor, with a ruined settlement and Plockton behind

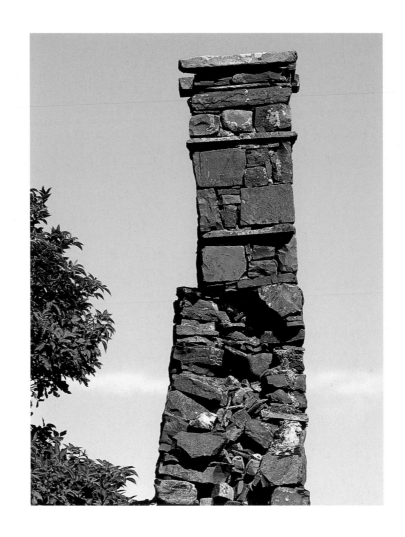

Remains of chimney on a ruin, east coast of Eilean Mor

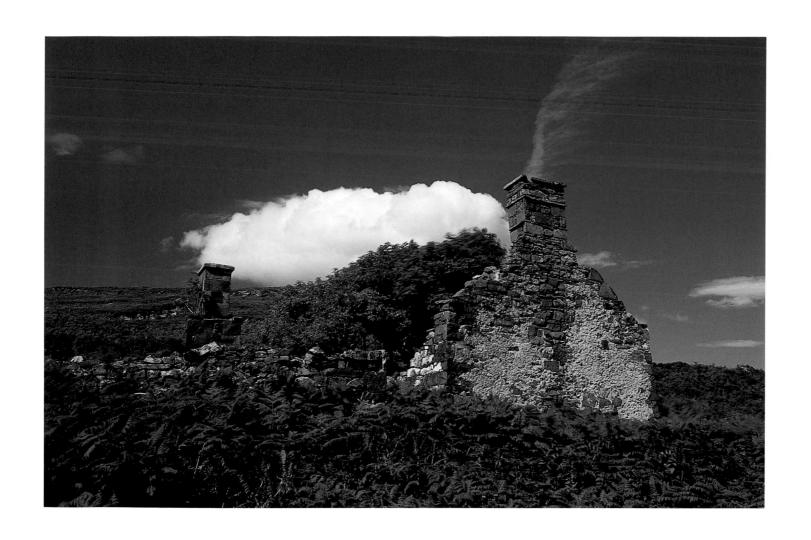

'Smoke' from a jet vapour trail above the ruins on Eilean Mor

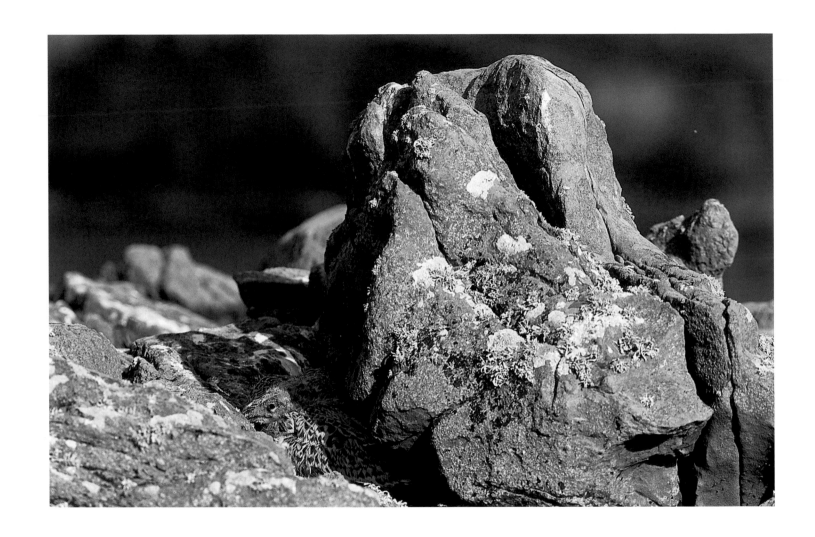

Two well camouflaged juvenile Lesser Black-backed gulls hiding behind a rock

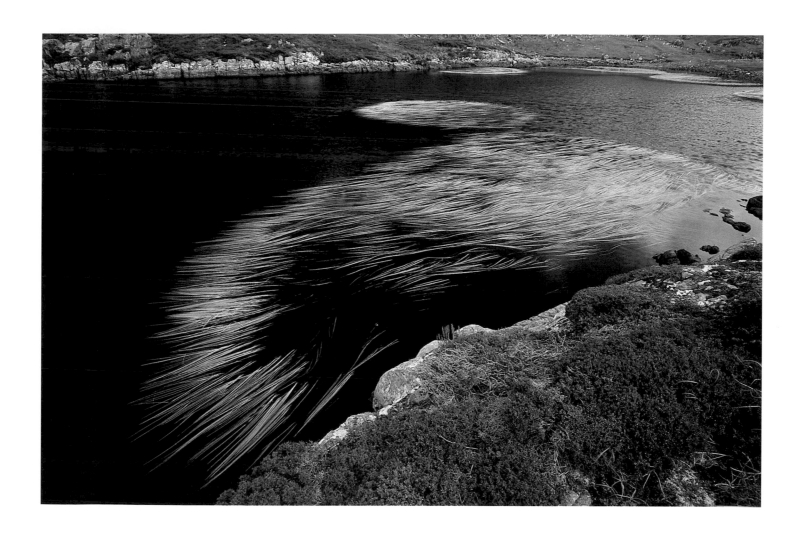

Floating Sweet-grass (Glyceria fluitans) on Lochan na Gleann, one of the island's eight fresh water lochs

Lichen covered boulder on the west coast of the island

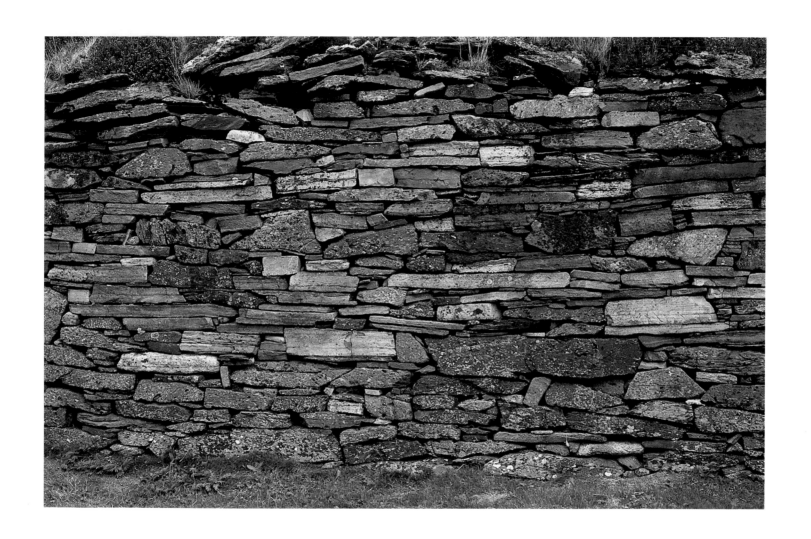

An example of the superb masonry evident throughout these islands, thought to date from the 9th century

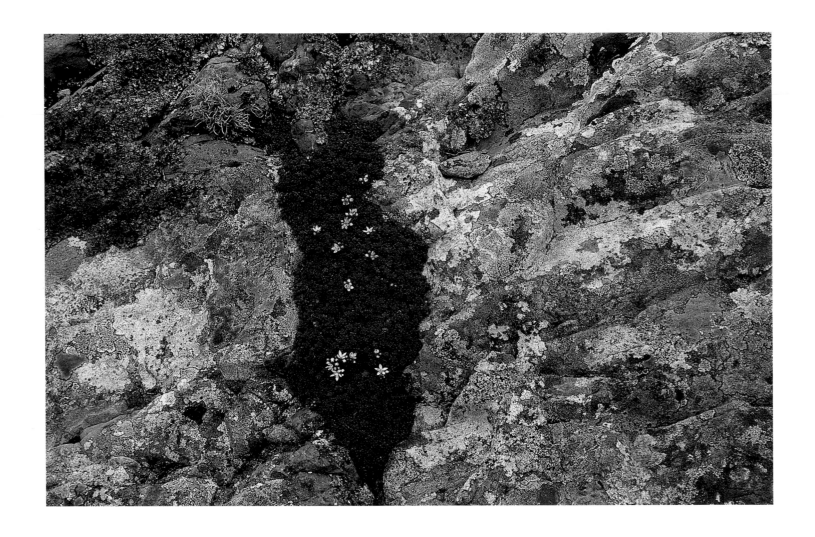

English stonecrop on Torridonian Sandstone above Lochan Fada

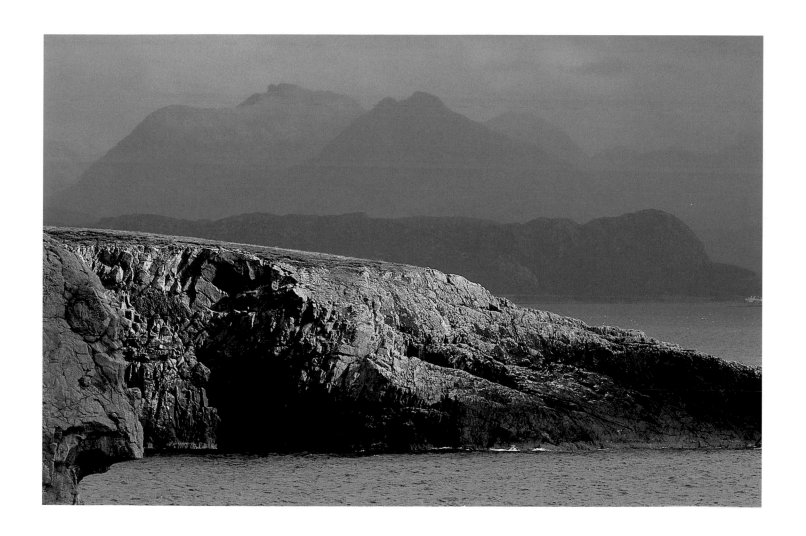

The mountains of Wester Ross looming behind the island

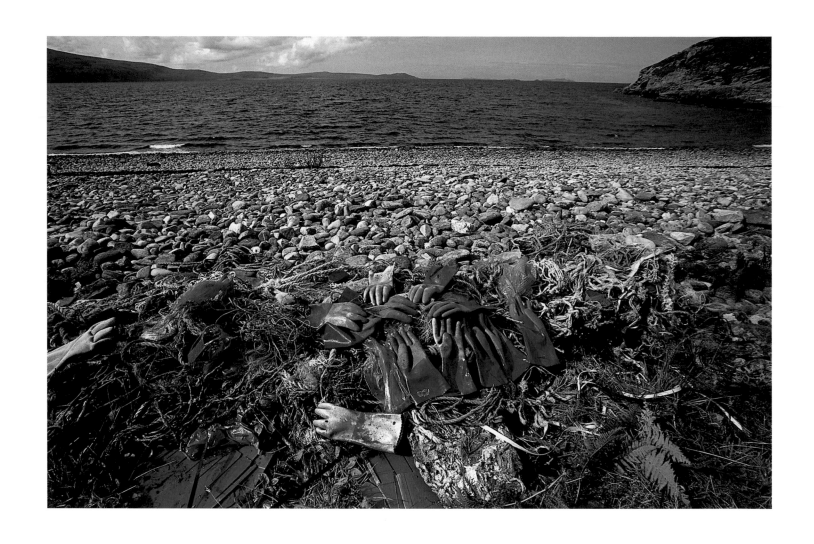

A pile of blue gloves lying as I found them on the west facing beach at Camas a'Bhuailidh

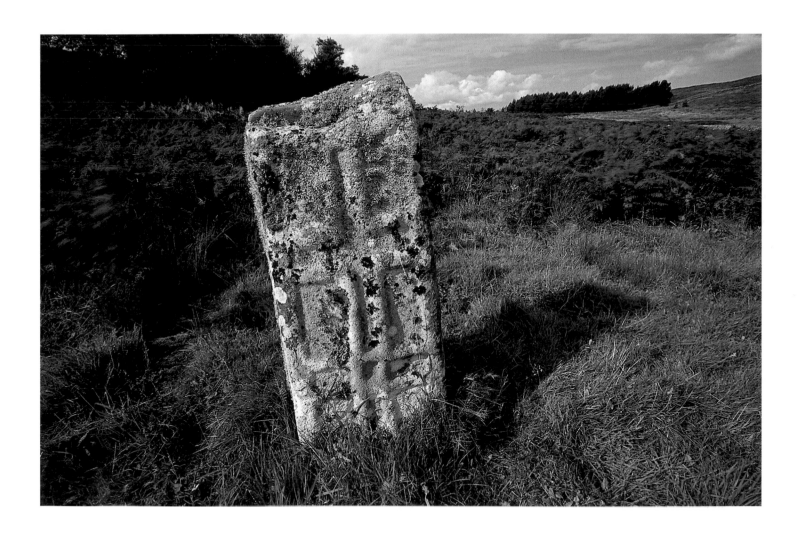

The cross stone in the fields near Rubha Beag

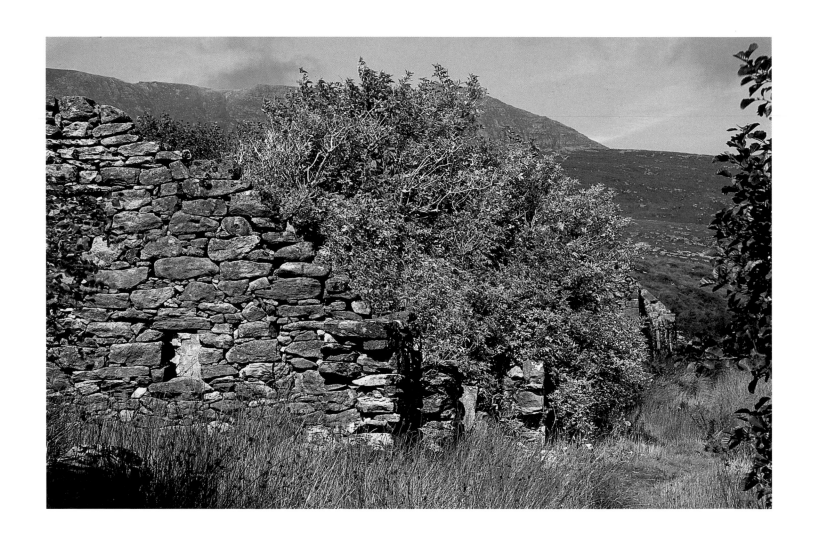

'The Street' in the ruined settlement on the east side above Loch Kanaird

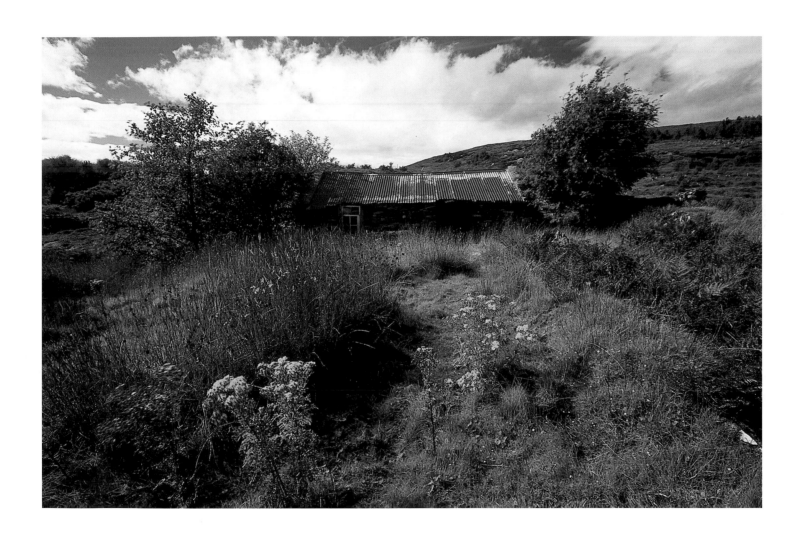

Lush summer growth and rusting corrugated iron, near 'The Street', above Loch Kanaird

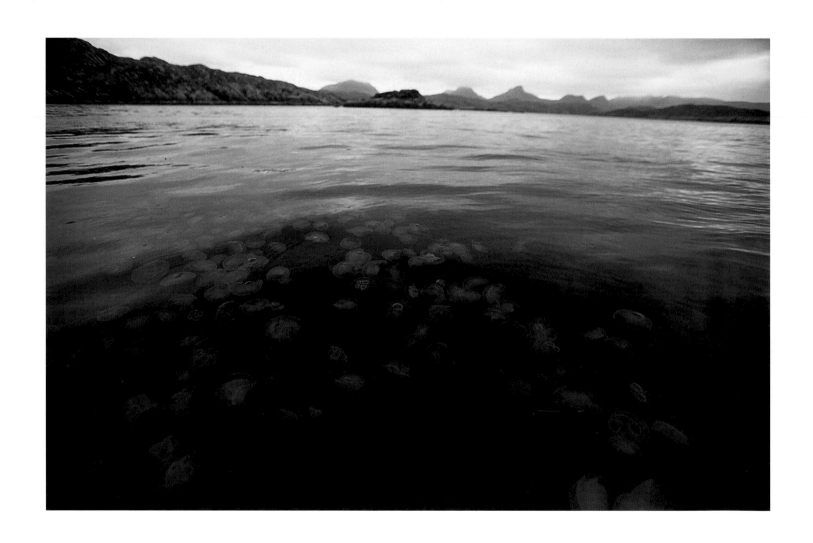

Moon jellyfish shoal near Lochinver

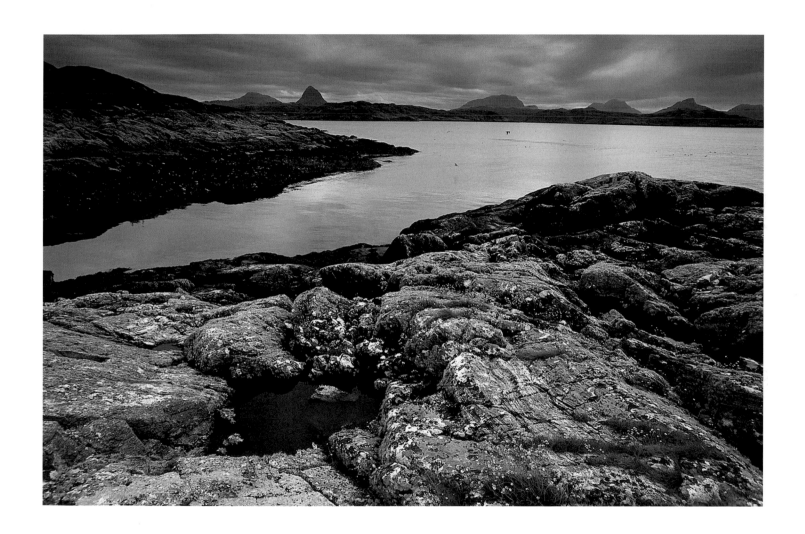

The mainland from Soyea Island, the distinctive peak of Suilven looming above the Sutherland landscape

Lazy waves from our boat reflecting cloud and sky, Lochinver